POWERCOLOR

POWERCOLOR

MASTER COLOR CONCEPTS FOR ALL MEDIA

CAROLINE JASPER

WATSON-GUPTILL PUBLICATIONS / NEW YORK

PREFACE

As a STUDENT, artist, and teacher, it seems forever that I have been looking for a comprehensive book about color. The important things I have read about color come from many different books, each having a narrow focus. Some discuss only color theory or mixing, others are about one artist, or one medium, or deal with color as a minor facet of broad topics like art history or psychology. When I imagined this book, I knew I wanted it to be the one-stop learning tool I always hoped to find. It would offer aspects of what fascinates and frustrates artists about color, mindful of the importance of concept over technique. And, since important works of art spring from originality, it would be both for and against color theory—assembled not for the purpose of setting out rules, but for clarification toward greater understanding and, ultimately, improved use of color.

COLOR'S MANY FACETS

Many different disciplines claim a stake in our overall understanding of color. This book touches on the many aspects of color that, in total, help us understand it more fully; they include science, physics, chemistry, physiology, psychology, theory, manufacture, and aesthetics. Physics deals with the visible spectrum of light energy and behaviors characteristic of differing wavelengths. Chemistry concerns literal pigment content, both natural and synthetic. Physiology has to do with our physical sensory experience, the eye's reception and the brain's perception of color light wavelengths. Psychology examines subjective color interpretation, along with symbolism in emotional expression and response. Theory represents academic tenants regarding color characteristics and interactions. Art materials suppliers oversee technical methods and standards in manufacturing color media. Aesthetics address color as a means to artistic ends. All of these concerns influence how artists think about and use color. The more you know about color, the more powerful your use of it will be.

HOW WE LEARN ABOUT COLOR

Color holds greater significance in today's art than in centuries past. We have access to better and more color, and know a great deal more about it than did our predecessors. Yet, how do we digest and make sense of so much information coming from so many different sources? Though it's important to absorb as much knowledge about color as possible from teachers, writings, and direct observation of artworks, it's usual for artists to reject, adopt, and/or adapt color information in the ongoing process of developing their own visual language of color. While information is power, it becomes meaningful only through personal application. Artists seek truths about color, not prescriptions.

Formal art education is much younger than all of art history, yet it too has evolved and expanded. Independent thinkers assimilate instruction rather than take it literally. Vincent van Gogh and Paul Gauguin both lacked formal training but read every color treatise they could find and drew different conclusions. While Van Gogh juxtaposed unmixed contrasting colors, Gauguin mixed color-value variations. Their heated debates about the use of color speak to strength in individuality.

Under academic influence, color gets ordered and measured, implying color formulas for art. All too often I have heard students ask, "What is the right way to…?" "How should it look?" or "What am I supposed to be doing?" Such "shoulds" and "supposed-tos" tend to block individuality. At exhibitions, we have all walked indifferently past artworks with which no technical fault can be found, then finally halted by truth in an image whose surface was applied crudely but honestly.

WHAT IS A COLORIST?

Color subjugates method. Whether thick or thin, liquid or solid, dripped or drawn, realistic or abstract, it is color, its choice and placement, that deliver a work's visual punch, not how it is applied. Artists who develop distinct color

approaches often become known as "colorists." Some have founded schools of color philosophy, some have written seminal treatises, and others have added to art history's "isms."

The work and firsthand words of several color-conscious artists, including my own, appear clustered at the end of each chapter in this book. In these "In the Studio" visits, each artist tells a different story with color, representing a wide range of media, subject matter, style, and method. Their color philosophies differ—products of personal vision, experience, training (assimilation and /or rejection of), and aesthetics. Some think of color more in terms of emotional response to subject. Some work colors toward realistic representation. Others are more interested in exploring color theory and method. At times, artists' thinking may alternate between expressive, representational, and formal concerns within a single work.

Rather than "how-to" formulas, artworks exemplify each artist's tendencies. None should be taken as artist-prescribed modus operandi. It is important to note that in instances when a painting is planned as a demonstration, the natural quality of that process becomes stifled by its planning. However, "In the Studio" no rules are suggested; there are no rules.

The placement of colorists featured throughout this book reflects a tangential connection between their work and the subject of the chapter they conclude. In truth, the essential points of the entire book can be discussed, in one way or another, in relation to the work of all ten of the featured artists. In the end, the particular emphasis of each artist's work suggested a natural fit with one of the book's five chapters.

CHAPTER ONE. WHAT IS COLOR? Though in very different styles, both Tom Lynch and Kitty Wallis are highly attuned to psychological color associations. They carry awareness of their own color coding into their work, and make no apologies for straying away from a subject's local color to play up an expression. Subjects are described as much by color shifts, personal style, and exaggerations as by underlying perspective or proportion.

CHAPTER TWO. MEDIA MÉLANGE Sean Dye and Bill James, both masters of a range of media, offer insights into how methods and color treatments vary according to media. Combinations of media and methods relate to knowledge of how colors interact, whether applications are opaque or transparent, and whether colors are mixed on a palette or artwork surface.

CHAPTER THREE. CHROMA CHRONICLES Jeanne Carbonetti and Thomas Nash are avid students of art history and its evolving color philosophies. They blend the heritage of cultures from opposite sides of the earth with contemporary color knowledge. Carbonetti applies Eastern philosophy to color expression; Nash's portraits echo Western traditions, yet with the application of extensive modern color-specification analysis.

CHAPTER FOUR. COLOR WHEEL CONFESSIONS Colorists' methods evolve from long-term fascination with color, along with personal intuition. Works by Camille Przewodek and Abby Lammers uniquely reflect their keen color comprehension. Lammers tests visual effects by varying local color. Przewodek responds to color perception comparisons during direct observation.

CHAPTER FIVE. COLORS IN CONTRAST Color consciousness for many artists reflects holistic awareness. Ever mindful of color, they intentionally allow it to influence what and how they paint. Although our subject, method, and media preferences differ, my work and that of Robert Burridge exemplify attention to color founded on pure enjoyment of it. We both consciously apply and combine color theory tenets without feeling bound by them.

> **The purest and most thoughtful minds are those which love colour the most.**
>
> JOHN RUSKIN (1819–1900)

INTRODUCTION: FINDING YOUR OWN WAY

No one ever learned to ride a bike by reading an instruction manual. A helping hand may provide guidance, and watching others can give you an idea of how to make it go. Eventually, you find your own balance in your own way. Art is similarly not "by the book." Unlike solving math problems or following anyone's directions, imagination bypasses "correct" answers. In coming to terms with color, artists must bridge the gap between *wheel* color (familiar primary and secondary colors associated with theory instruction) and *real* color (actual pigments). Perceiving color in life, reacting to it in a certain context, then finding a way to respond to it with color material is an indefinably personal process.

> **When a critic suggests that something is not worth doing because it has been done before, he is in effect urging an artist toward one of the more exciting aspects of art, the attempt to achieve the impossible.**
>
> FAIRFIELD PORTER (1907–1975)

Developing artists sometimes focus so steadfastly on rendering local color or schematic memorized images of their subjects that they forget to really *look*. Experienced artists learn to not take the observed world at face value. Instead of painting how they think they see subjects, they think about how they see and paint according to how they want their interpretations to be viewed. Mature artists realize that putting their own spin on perception is what leads to meaningful personal expression and communication with viewers.

To impart to the viewer something of an artist's personal take on a subject, the artist must think about the subject differently from how others might. Local color, which accounts for the extent of what most people notice, may become secondary in the artist's observations. The artist thinks about reflected color, comparing one color next to another, at times forgetting the subject. To portray all of that on a flat surface, the artist has to know color and understand how color applications visually interact on canvas.

"You are here to represent by color, by separation of color, by exact matching of color, what you see, and thereby learn to see." Those are the words of Charles W. Hawthorne (1872–1930), a much-revered teacher of many artists, as noted by a student at his Cape Cod School of Art. Bypassing taste, design, and technique, Hawthorne encouraged a stratagem of seeing color and light for pictorial art. He trained students to see color "spots"—avoiding contour drawing—and to record color plane relationships.

Though we all must find our own way, *along* the way it helps to find inspiration and guidance from visionary mentors and the work of other artists—your own cadre of heroes who dared (or dare) new ways with color. One of my own color heroes is Fairfield Porter. Harvard educated, Porter also studied in Europe and at The Art Students League of New York. Yet, his work shows little evidence of academic training and is seemingly unaffected by trendy mid-twentieth-century art movements. In Porter's paintings, virtuosity of brushwork does not distract from an honest read of his subjects. Standing on the shoulders of Post-Impressionists like Paul Gauguin and Paul Cézanne, Fairfield Porter is favored by critics for simplifying shapes in his own way. Bridging realism and abstraction, his flat color planes define form without detail.

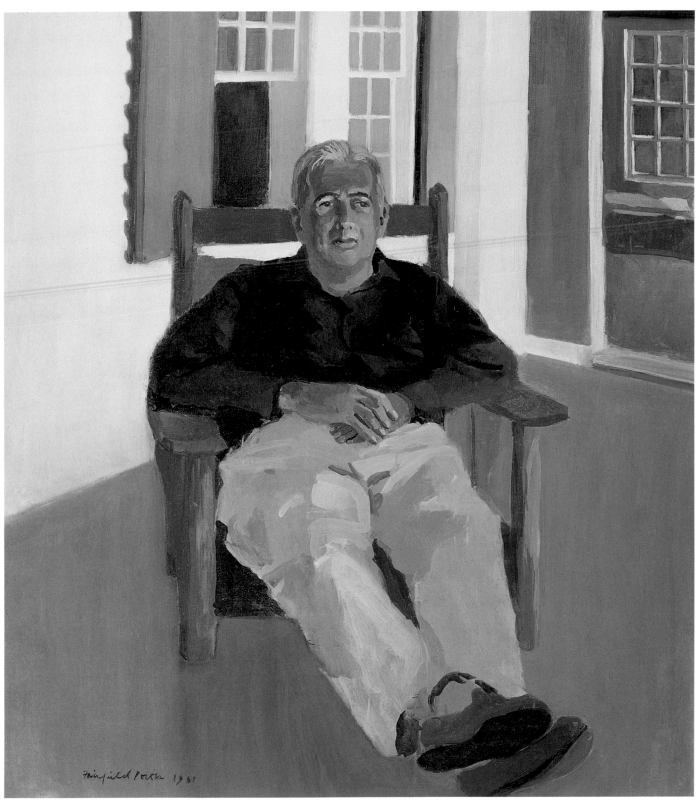

Fairfield Porter. *Michael W. Straus.* 1961. Oil on canvas, 45 × 39 1/2" (114.3 × 100.3 cm)

Collection of Diane and David Goldsmith, California

Color is primal, visible all around us, and often essential to survival in nature. Colors help us distinguish one thing from another, aiding a quick read of surroundings. Things with color have greater appeal than those without. Colors constantly affect us in our daily lives—they stimulate emotional responses, help us navigate roadways, and cause photochemical changes in substances sensitive to light.

As a universal means of communication, color is fundamental to the visual arts and is perhaps its dominant element. How color is used can sway viewer response. It can grab attention, identify content, and suggest meaning. Yet, since artists look to color not only as a means of objective representation but

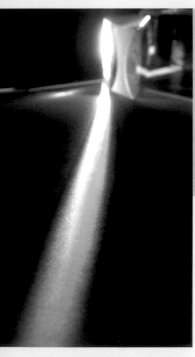

White light contains all visible colors, each of which has a unique wavelength causing it to bend at a different angle. This prism is refracting white light into a multicolored view of the spectrum.

WHAT IS COLOR?

also of expression and design or decoration, how they interpret color is as important to their art-making process as the physical color vision that enables them to observe their subject. Artists base their choice and use of color on personal views, literally depicting what they see while psychologically editing it.

Today our understanding of color is richer than ever, standing on contributions from several different camps—among them, nature, physics, psychology, physiology, chemistry, aesthetics, history, and culture. This chapter touches upon the multiple definitions of color artists explore as they seek to master color and use it for their own distinct purposes.

ART AND SCIENCE IN YOUR EYE

THE MORE artists learn about color physics and optics, the more prepared they are to communicate with viewers' eyes and brains. Understanding how the brain perceives the real world in living color enables an artist to trick a viewer into seeing what the artist wants him or her to see on a flat painted surface. When first learning about color, many are surprised to learn that things we see are not really colored, and that color is not created in our eyes. The truth is that it is all in our minds. Color is an illusion—something our brains perceive. Color results from light, surface, and eyesight. Together, physics, physiology, and psychology account for the way we see color.

Light is the source of all color. Without light there would be no color, only darkness. While some color is self-luminous, radiating in all directions from electromagnetic disturbances, most results from reflections. Surfaces reflect light differently, causing a specific color appearance.

COLOR ENERGY

The earth's environment is filled with a largely invisible electromagnetic energy field, known as the *electromagnetic spectrum*. Light, but a small part of that field, embodies the only visible energy, which we call *color*. Light energy waves, not actually colored, differ only in length and rapidity. *Wavelength*—the distance from the peak of one wave to the peak of the next—is measured in units called *nanometers*, corresponding to CPS (cycles per second) frequencies. The visible color spectrum includes 400 to 700 nanometer wavelengths beating at 350 to about 400 billion vibrations per second. Within a range of wavelengths, colors are accepted as some type of red, blue, yellow, and so on. The longer and most slowly vibrating wavelengths begin with red then gradually shorten and quicken from yellow, green, blue to violet. Because wavelengths bend at different angles, their reflective behaviors differ as well (see illustration on opposite page).

VISION MECHANICS

We can perceive hundreds of thousands of different color sensations by way of light entering the pupil. The human eye, once thought to be a source of light, is a receiver that collects light data and passes it to the brain where color discernment occurs. The workings of the eye are often compared to a camera. However, no image is formed on the retina like the upside-down, reverse image recorded on film in a camera. The *retina* (from the Latin word for *net*) catches incoming light along the eye's internal lining via two classes of photoreceptors called *rods* and *cones*.

Cones, centrally concentrated where few rods are found, form the retina's color-reception headquarters. Consequently, color is more easily recognized when centered directly in front of the eye. Three different cone types each contain a distinct *photopigment* sensitive to a separate portion of the color spectrum. Cones sensitive to blue (short wavelengths) surround core red and green cones (sensitive to long and medium wavelengths). When all three are equally stimulated, the brain perceives white. If green and red cones are set off, but not blue, we see yellow. Since few surfaces reflect colors in simple terms, it is much more complicated than just one or two cones firing at a time. Things that we think of as red, green, or blue reflect a range of wavelengths. Activated in varying

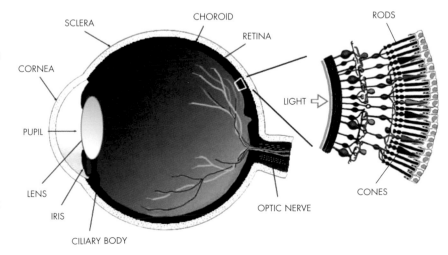

A schematic section of the human eye with a detail of the retina

SCLERA

CHOROID

RETINA

RODS

CORNEA

PUPIL

LENS

IRIS

CILIARY BODY

LIGHT ⇨

OPTIC NERVE

CONES

degrees and combinations, cones together generate an enormous range of color sensations, far more than our language can specify.

The brain receives dark/light data more directly than color data. Since rods are highly light-sensitive, they enable us to see in very dim light; yet, rods are nearly blind to color, which is why our ability to see color at night (via rods only) is so diminished. We perceive differences in light more readily than in colors due to the retina's broad rod distribution, compared to the strictly centered cones. Unlike the single and separate cone function, rods team signals onto one optic nerve fiber. This accounts for the importance of value over color in visual impact.

Cone and rod responses are just the crude beginnings of color processing. Data sorted singly for each eye generates depth perception. Though discerned separately, the physical properties of light that characterize hue/wavelength, intensity/luminance, chromatic purity/saturation, and achromatic energy levels comprise full color vision. Normal color vision is *trichromatic*. If one or more cone types lack normal color sensitivity, the result is what we call *color blindness* (affecting 8 percent of the population). The ability to perceive color differs between individuals and lessens with age. Just as some people have an ear for music, others have an eye for color.

WHAT YOU SEE IS WHAT YOU GET

All that we see is direct or reflected light, with a huge energy level difference between the two types. Surfaces cannot reflect the full strength of light that strikes them. Paints and supports—such as canvas or paper—therefore lack the brightness and clarity of actual light. If white paint could equal the sun's glare, viewers would have to squint at paintings. Artists must resort to trickery to represent on painted surfaces not only reflected light but also the intensity of light and color visually experienced in sunlight.

Surfaces reflect some light wavelengths and absorb others. We think of things as being colored, yet what we are seeing is the color of only the reflected light since all other colors (wavelengths) of light have been absorbed, or *subtracted*. A red rose, for example, looks red because it reflects only red light. All other colors have been absorbed—that is, subtracted from the visible spectrum. Red under green light looks black. Since green light waves contain no red, all is absorbed leaving no light to reflect. Seeing color is just seeing light, one portion of the spectrum at a time. Multiple combinations appear in infinite variety, though seldom in pure single-wavelength form.

PHYSICAL CONFLICT

Fundamental differences between color in light and color in pigment have long been a source of confusion for artists. Ever since Sir Isaac Newton initiated scientific study of color optics (the physics of light), artists have debated how to reconcile the fact that color physics does not provide a basis for mixing paint colors. For example, red and green are light primaries but pigment complements. Familiar with dull color

The white eggshell reflects all colors.

A red apple reflects red light but absorbs blue and green light. (This is an oversimplification for the sake of example. We do not actually see real apples of one solid single color.)

mixtures of red and green paint, artists are often surprised to learn that mixing red and green lights produces yellow.

Light primaries—red, blue, and green—together form white light. Adding light adds more energy, making color brighter. However, when artists' color primaries—red, blue, and yellow—are combined the result is gray. More colors added together on a surface will absorb more and reflect less light, making color duller. Simply put: lights added = more light; pigments added = less light.

Additive and *subtractive* color systems are easily confused. Artists think of mixing colors as an additive process. Yet red, blue, and yellow are additive only in terms of mixing paints, not optically. Pigments are nonetheless viewed according to the same laws of physics that govern all color vision. A green color, mixed from yellow and blue paints, is seen as green because the green paint's surface reflects green light while absorbing red and blue light waves. Paints are mixed by pigment addition, yet seen by light subtraction.

COLOR APPEARANCE

Colors do not always look the same. *Local color* is the color seen in an unaffected setting under a balanced light source. Direct sunlight on a clear day is most reliable for determining local color. While we can see and recognize things regardless of the type and amount of light present, color appearance may differ to extremes. As an artist, the challenge is to paint what you see (how color looks at the moment) instead of what you think you see (a memorized, expected local color).

Various light sources generally referred to as "white" differ in content. Sunlight delivers all or part of the visible spectrum depending upon outdoor conditions. Artificial light, which has a limited spectrum, varies even more. When light direction, angle, or environment changes, so does the color of surfaces illuminated by it. With seasonal and daily time progression, sunlight strikes the earth from different angles, modifying light reflection and thus the appearance of colors as well.

ADDITIVE-COLOR LIGHT FORMATION. Light projection illustrates the physics of light and color. All three primary-colored lights—red, blue, and green—superimposed on a black background form white light. Where color light beams overlap, red and green make yellow, blue and green form cyan, and red and blue create magenta.

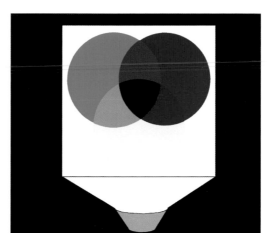

SUBTRACTIVE-COLOR LIGHT FORMATION. Transparent disks of yellow, magenta, and cyan each filter out (subtract) one of the primary colors from white light: yellow absorbs blue; magenta absorbs green; cyan absorbs red. When all three subtractive colors overlap, black results because no part of white light can reflect.

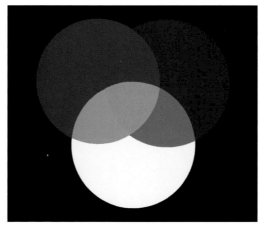

PIGMENT COLOR FORMATION. Primary colors—red, blue, and yellow—mix in pairs to create secondary colors: red + blue = violet; blue + yellow = green; yellow + red = orange. All three primaries together create a neutral gray tone.

Red and green pigments mix to make a neutral brown (unlike the mixture of red and green lights, which together create yellow).

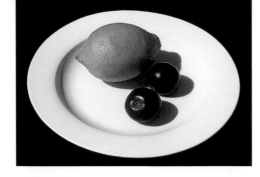

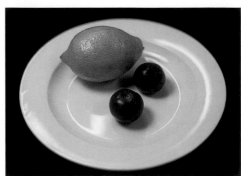

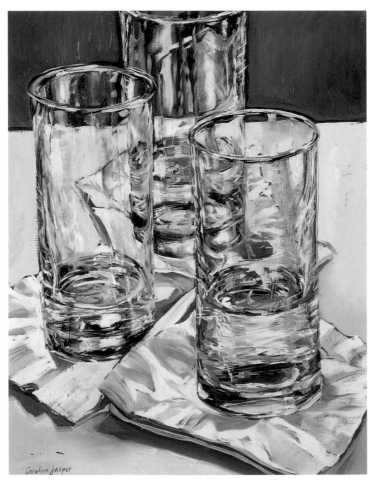

Caroline Jasper. *Late Night Empties.* 1994. Oil on canvas, 28 × 22" (71.1 × 55.9 cm) *Collection of Dan Whipps Photography*

The objects in *Late Night Empties* are either clear or white. Other than inventing a Viridian background, all other colors recorded exaggerate hints of color reflected from surroundings. As the painting on an easel beside the actual still life became more colorful, it reflected back onto the glassware, increasing the volume of observed color there.

Atmosphere and weather can further affect light balance. Under bright light, colors tend toward yellow, but in dim light shift toward blue. At noon, on a clear day, a red rose displays its natural red. Early morning mist or late afternoon twilight alters its redness. Having registered the rose's bright sun version, we still think of it in terms of its actual red despite color shifts.

A color's value affects its reflective quality. Lighter colors are more visible in dim light while darker colors lose identity and seem to disappear in shadows. Some surfaces can absorb only so much light. If light is too bright, they get overtaxed, producing glare (excess reflection). Wavelengths (colors) that might otherwise be absorbed instead reflect, changing surface color appearance. Colors change with light levels. Bright colors hold up best under strong light. Darker colors show up well under bright light but shift in hue. Lighter colors brightly lit tend to look washed out.

All objects look blue very early or late in the day when the *Purkinje shift* (a phenomenon named for the physiologist who explained it) occurs. Rods, having greater sensitivity to light, continue reception under light conditions insufficient for cones to function. When illumination is reduced, we may still be able to see things; we just will not be able to discern their "true" colors. Blue-sensitive cones, residing more in the retina's rod territory, continue to signal data to the brain as light dims. Therefore, in darkness, cool colors generally look brighter, and thus lighter in value, than warm colors.

Artificial light sources all shift natural color appearances. Standard tungsten lightbulbs contain many wavelengths but do not equal full-spectrum sunlight. Incandescent lights have a yellow dominance. Fluorescent bulbs radiate a narrower range of wavelengths. Lights often used for public parking lots cast a blue-violet look. Remember that surfaces can reflect only the light that strikes them.

Surrounding surfaces can also influence color appearance (see *Late Night Empties*). Light hits a surface and reflects outward in all directions, bouncing back and forth among

things. Not only do different types of surfaces—curved or flat, for example—reflect light according to their shape and angle to the light source, but they will also reflect their own local color and hints of nearby colors. Color reflections further vary in brightness and value depending on the nature of the light source, its direction and intensity, as well as the tactile qualities of surfaces from which they bounce.

Graduating from the coloring book mentality of "the sky is blue" and "apples are red," artists learn ways to alter color mixtures when representing observed lighting differences. For example, painting outside on different days or working both inside and out on the same painting can present color challenges for artists. Thomas Nash recalls that the group in his *April and Children* originally posed on an overcast day under a porch roof. The painting was finished after many additional studies both in the studio and in the yard. He claims, "An approximation of a sunny day can be created in the studio by use of a very large warm light, remembering that the light rays are not quite the same as from the sun." While he does not recommend this as a complete substitute for working outdoors, he admits, "It can be an aid while visualizing the painting."

HUE NAME IT

The word *hue* suggests color name generalization. It is associated with each of the six different color clusters—red, orange, yellow, green, blue, and violet—that we use to identify the full spectrum. As children we learn to describe colors in such generic terms. Apples are referred to as red despite the fact that an apple's surface is not color consistent. Even as our language develops into adulthood, we continue to apply basic color tags. And, even though commercial products and everyday descriptions include endless names for colors, the spectral hue reference is common. Instead of stating wavelength measurements, we tend to specify colors by their similarity to the six basic wavelength sectors. We simply attach modifiers to them: for example, *lemon* yellow, *sky* blue, *pea* green, and so on.

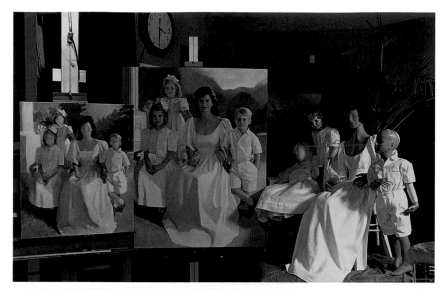

Thomas Nash's *April and Children* (incomplete) is flanked by a one-quarter-size study and manikins with subjects' clothes. The light source, not visible, is warm incandescent.

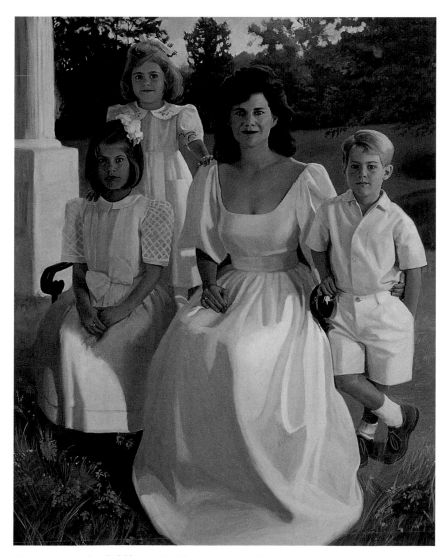

Thomas Nash. *April and Children.* 1998. Oil on linen canvas, 60 × 48" (152.4 × 121.9 cm)
Private collection

PSYCOLORGY: SEEING WHAT YOU THINK

COLOR PERCEPTION goes beyond vision mechanics. Although generalities apply, each person brings personal baggage to color interpretation. Colors differ in lightness and darkness and have the ability to affect feelings accordingly. They affect our nervous systems, prompting alarm, arousal, caution, joy, and more. The human psyche is embedded with color signals. Whether from personal experience or cultural training, color psychology infuses our experience of visual art. And since many color effects are universally shared, even traversing cultures, it is perhaps the most effective tool of visual communication between art makers and viewers.

COLOR CODES

Color meanings have a long history, linked in antiquity with the basic elements—earth, air, water, and fire. Many color associations are learned from sensory connections so common to human existence as to be universal. Color coding has been practiced for centuries to define ceremonial purpose, social status, religious symbolism, and personal identification.

Medieval knighthood investiture required a white tunic to indicate personal cleanliness, a red robe to represent willingness to shed blood for the church, brown stockings as a reminder of eventual internment, and a white girdle to symbolize chastity. A color system for heraldic coats of arms evolved out of a need to identify jousting participants whose faces were hidden under armor. Animal images, precious gems, and astrological signs supported moral color interpretations. A shield depicting a red lion meant strength and eagerness to fight. Many of today's sports team colors evolved from such origins.

Color connotations mutate according to differences in value, brightness, or hue shifting. Pink, for example, though derived from red, is quite passive by comparison. Painting jail cells pink proved effective in calming violent tendencies among inmates. For each color's prevailing suggestion there may also be an opposing association, often indicated by specific artistic content.

Color codes guide art interpretation. The color of clothing, props, furnishings, buildings, backgrounds, and so on help create meaning. And color dominance—when one portion of the palette is excluded in favor of another—implies an expression or mood associated with that color.

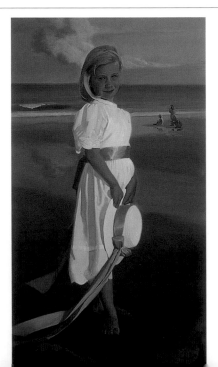

Thomas Nash. *Tyler.*
1995. Oil on linen
canvas, 52 × 28"
(132.1 × 71.1 cm)
Private collection

WHITE is clean, innocent, good, and pure. It is the height of light and brightness, and, as a traditional symbol of holiness, is worn by Christ, angels, and brides. According to biblical description, pearls adorn heaven's gates. The ancient Greek word for white meant happiness. Priests of Apollo, god of light, wore white robes. On the first of the year, according to myth, a white-robed horseman rode a white steed up the capitol to celebrate Jupiter's triumph over the spirit of darkness. Yet, white can also stand for helplessness.

Color in Thomas Nash's portrait of Tyler supports the innocence implied by the young girl's white dress. Clouds, surf, and dress appear white. Yet pure white paint is minimally used. Pink ribbons along with water and sky blues reflect onto the dress. Since viewer response to color is automatic, regardless of artistic intent, colors speak for themselves. However, regarding his use of white, Thomas Nash disclaimed, "I would not want to attach any meanings about purity or other psychological things to its use with any of the portraits." Nash uses white for its "timelessness" or due to client preference. "White can be flattering against skin tones, bringing out the color," he explains.

GRAY is neutral. It lacks color identification or value significance. It goes unnoticed. Gray is noncommittal, stable, practical, and perhaps somber, as in Sean Dye's knife painting *Pumpkin Light, Deer Isle, ME*. Grays hint of afternoon blues and violets.

Sean Dye. *Pumpkin Light, Deer Isle, ME*. 2002. Oil on linen panel, 18 x 24" (45.7 x 61 cm) *Collection of the artist*

BLACK is darkness and evil. Much is hidden in it, perhaps feared. Black suggests demons, death, defilement, horror, mourning, and despair. Traditional for funerals, black is also elegant fashion, formality, and prominence. Black sable fur was prized as "black gold" during the Middle Ages and the Renaissance. Whether for Dracula's cape or a sexy evening gown, black is powerful.

Black is the focus in Kitty Wallis's essentially black and white portrait *Fast Talker*, though it does not dominate. It supports her comment on the subject's character.

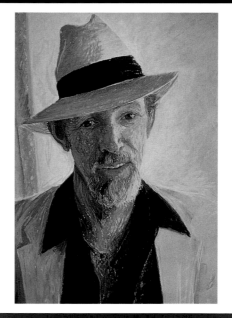

Kitty Wallis. *Fast Talker*. 1980. Pastel on sandpaper, 28 x 22" (71.1 x 55.9 cm) *Private collection*

RED is passion. It is the blood of life, long associated with fire, the sun, divinity, and strength. Aristotle suggested red as the shadow side of light. Ancient Greeks used red to sanctify both weddings and funerals. Romans, emulating their Greek predecessors, painted their temple walls and statues in red. The red and white tablecloths so prevalent in restaurants today are rooted in religious traditions of red and white decorations for joyous feasts. Santa Claus's suit, Superman's cape, and carpeted celebrity paths all speak to red's authority. Fire engines, flashing police lights, and stop signs signal red's sense of alarm. Red stripes in the U.S. flag symbolize blood shed in the fight for freedom. From valentines to violence, red emotes strong feelings. Red-orange is even hotter and more emotive. Slightly cooler reds—crimson, carmine, and red-violets—suggest power, but of a more spiritual nature. Red's potent negative implications relate to the devil, lasciviousness, wrath, and cruelty.

My *Red Attitude* imparts the color's emotional power. I find that wearing red can feel empowering and am quite partial to these red shoes, despite the pain involved in wearing them. Backed up and standing alone, their pointed high-heeled heat challenges the viewer.

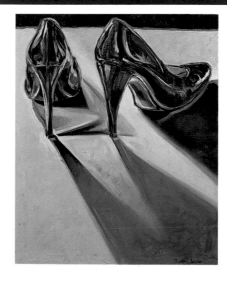

Caroline Jasper. *Red Attitude*. 1994. Oil on canvas, 32 x 24" (81.3 x 61 cm) *Collection of the artist*

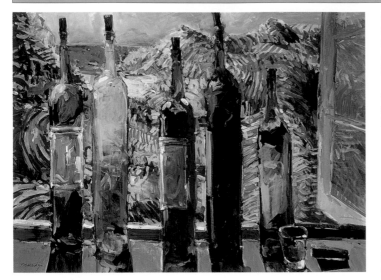

ORANGE is fire. At the hottest point on the color wheel, it represents maximum radiant warmth. Its glorious, untamed, explosive wildness signals strong spirit and perhaps danger. Scarlet, a vivid, red-leaning orange, is festive yet powerful enough to symbolize adultery in Nathaniel Hawthorne's puritanical novel *The Scarlet Letter* (1850).

The title of Robert Burridge's *By the Beautiful Sea* belies its firey color content. Oranges, yellows, and reds inflame spaces between simple bottle forms. Blues and violets incite the contrast along with highlight accents and glimpses of the horizon.

Robert Burridge. *By the Beautiful Sea.* 2000. Acrylic on canvas, 36 × 48" (91.4 × 121.9 cm) *Private collection*

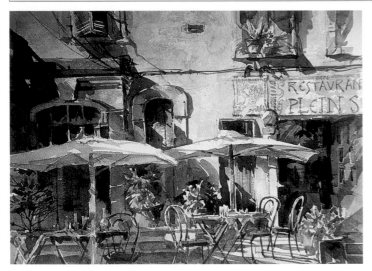

YELLOW is energy. It is lighter than other colors of equal brightness. High visibility makes yellow a logical color to signal caution on road signs, taxicabs, fire engines, and crime-scene tape. Yellow is the color most like gold. It also accompanies the daily arrival, departure, and brightest glow of the world's primary power resource. Sun worshiping, known to many primitive cultures, attests to yellow's affiliation with divine enlightenment, healing, and redemption. Implications of joy and restlessness come from ancient uncertainty that the bountiful sun would return each day. According to some Christian iconography, yellow is interchangeable with white to represent light and God. Bright yellow is worn by Tibetan monks and is also a Chinese imperial color. Yellow also adorns happy-face stickers everywhere. On the negative side, yellow is a jaundice color, one of sickness and disease. Diluted, it can symbolize cowardice, deceit, and meanness.

Umbrellas in Tom Lynch's *Van Gogh's Colors* imply the sun's warming influence on the scene's dominant yellow. Even cooler violets and greens seem brighter in context with dark/light and yellow contrasts.

Tom Lynch. *Van Gogh's Colors.* 2003. Watercolor on paper, 15 × 22" (38.1 × 55.9 cm) *Private collection*

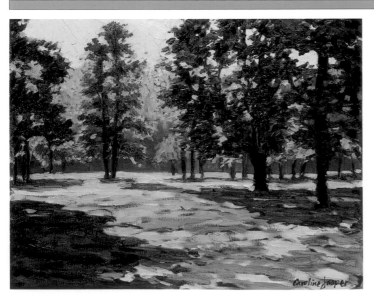

GREEN is life. Youth and inexperience naturally relate to green. Bright "spring" greens usher in the earth's season of renewal, supporting affiliation with life and health. Green's expression sways with bias toward yellow or blue. Warmer greens seem joyous, cooler greens are calmer. Jealousy and envy are green's negative associations.

As suggested by its title, greens were the focus in my *Verdance* landscape. Greens of all kinds, both mixed and straight from the tube, appear on this canvas. Their lush appeal is heightened by the red-ground contrasts throughout.

Caroline Jasper. *Verdance.* 2002. Oil on canvas, 16 × 20" (40.6 × 50.8 cm) *Private collection*

BLUE is peace. It is always passive, both spatially and spiritually. Calmness and coolness come with fresh air, clear blue skies, and a panoramic ocean view. The constancy associated with blue suggests truth, wisdom, order, and fidelity, befitting police and naval uniforms. Blue, prominent in early Christian representations of eternal light, is a dominant color in stained glass church windows. According to an ancient Jewish notion, God dwelled in darkness, in a light not visible to man, represented by the color blue. Sapphire stones, having a prestigious tradition of divine affiliation and protective powers, were also used in medical treatments. The Chinese symbol for immortality is blue. On blue's negative side, it implies sadness and depression, even death.

The title *Morning Blue* speaks to Kitty Wallis's focus in this scene from Giverny, France. While a full palette of colors appear (perhaps honoring Claude Monet), blue and its relatives, blue-greens and blue-violets, dominate the canvas and set a tranquil mood.

Kitty Wallis. *Morning Blue*. 1986. Pastel on paper with watercolor underpainting, 30 × 22" (76.2 × 55.9 cm) *Private collection*

VIOLET is royal. Since antiquity, violet has been prized not merely because of its beauty. Due to expense and limited availability violet became exclusive to rank and royalty. Red-violets, such as magenta, seem more romantic, impressive, and stylish. Blue-violets suggest reflective moodiness and mystery. In early Christianity, violet, because of its natural darkness, was associated with black and reserved for feasts of mourning and penance. Depending on value or temperature leanings, it can have diverse implications. The term *violet* is interchangeable with *purple*, its less academic name.

While painting *Dawnlight Dance* I used color to influence mood. It was a summer morning, a time of day when the temperature rises quickly with increasing sunlight. Violet reminded me of the solitude I relished at daybreak that would soon be interrupted by activity and bright sun.

Caroline Jasper. *Dawnlight Dance*. 2000. Oil on canvas, 24 × 32" (61 × 81.3 cm) *Collection of the artist*

BROWN is earthy. It can be sensuous like chocolate or strong like coffee. It can also be crude, decaying, or dirty. Either way, brown is down-to-earth real. Depending on its bias, brown can lean toward any color on the wheel. Seldom are browns entirely neutral.

Kitty Wallis offers a close view of ripe earth on the verge of a new season in her *Tesuque Spring*. Color and textural variety make it at once gritty and sumptuous.

Kitty Wallis. *Tesuque Spring*. 1980. Pastel on sandpaper, 22 × 28" (55.9 × 71.1 cm) *Private collection*

IN THE STUDIO: TOM LYNCH

ABOUT THE ARTIST

A distinguished watercolorist for more than thirty years, Tom Lynch's credentials include honors in North America and in Europe, including two lifetime achievement awards. He has been elected into the American Impressionist Society and is the first American selected to honorary membership in the Canadian Society of Painters in Water Colour. He is also in *Who's Who in American Art* and has signature memberships in many national watercolor societies. He has had solo shows at the American Embassy in Paris and in many leading American galleries.

Lynch is an international workshop instructor and the author of six books, four television series, and numerous videotapes. His work has also been published in *American Artist* magazine, *International Artist* magazine, and *The Artist's* magazine.

COLOR PREMISE

As a professional artist and teacher for over thirty years, Tom Lynch considers his philosophy and teaching "slightly 'left' of the norm in the realm of color." From his traditional commercial, fine, and figurative art school training Lynch was instilled with color terms of hue, value, and tint. Regarding his approach to color he says, "As a landscape painter I never really admired anyone's ability to get the color of a tree trunk or a sidewalk 'just right'. Once you struggle to capture the 'right' color, other artistic factors play in—such as changes needed for lighting, proximity of depth, etc. Even more important to me is how color affords the viewer a level of entertainment that diminishes any need for detail."

Lynch makes subjects more colorful than they really are to increase his and others' enjoyment of a scene. Bright colors make viewers "feel good," he says. Lynch strives for simplicity of detail. "As I take away from viewers the opportunity to view detail and realism I must give them something in return," he explains. Lynch compensates with variety in color. He devises unique lighting for drama and moves colors beyond realism toward mood.

COLOR METHOD

Tom Lynch follows the notion that "all artists should evolve." He recalls, "One day I was elated to find a beautiful mixture of Yellow Ochre, Permanent Magenta, with a touch of Cerulean Blue for concrete sidewalks and thought of how this would bring greater accomplishment to my frequently painted hometown Chicago scenes." This seemingly simple observation was a seed of change for the artist. Now, instead of making paintings to report what he literally sees, Lynch wants to "entertain and stimulate viewers' imaginations." He achieves this with "an exaggeration of color and constant change, not all of which are true to the subject." He explains that some color changes "stir things up and open a door to creativity both in painting and viewing."

STUDIO PRACTICE

Watercolorists, due to the medium's inherent transparency, generally work from light to dark on white paper. Tom Lynch starts with the brightest colors manufacturers make, reasoning, "It is easier to gray down a bright color than to brighten up a dull one." He then selects light, medium, and dark versions of each color for convenience in portraying value changes on differently lit planes or layers in depth. Lastly he chooses a few specialty paints, which he calls "juice" colors, reserved for impact areas. Lynch claims Royal Blue as the basis for all of his darks and identifies Burnt Sienna as an earth color favorite. He notes greater use of blues in northern subjects and more warm colors like Cadmium Yellow Orange in southern and southwestern scenes. When painting flowers and gardens, the artist adds pastel colors such as Brilliant Pink, Lilac, and Lavender to his palette. For many years Tom Lynch mixed all of his greens, but since becoming more involved with painting golf courses he has added three tubed greens.

ARTIST'S PALETTE

Cerulean Blue, Cobalt Blue, Ultramarine Deep Blue, Peacock Blue,* Permanent Yellow Lemon,* Aureolin, Yellow Ochre, Burnt Sienna, Cadmium Yellow Orange, Permanent Red, Permanent Magenta, Alizarin Crimson, Royal Blue, Permanent Green #1,* Permanent Green #2, Hooker's Green, Opera*

* "Juice" colors, which the artist describes as "very intense, almost iridescent."

His prefers Holbein Artists' Water Colors. Lynch notes, "There is greater color saturation in this brand, so they perform better for my impact areas. Their strong darks do not turn orange and dirty. Additionally, they reliquefy allowing for lifting color from dry areas." For years Lynch exclusively used Gemini paper since "it does not allow color to soak in as fast or as far into the surface as other brands. This is especially important to my colorful washes, spray bottle and lifting techniques." More recently he has been using watercolor canvas from Fredrix, which offers a practical solution to working on a larger scale (since canvas does not require framing). He paints with long-handled, longhaired Kolinsky brushes made by Stratford and York.

Lynch likes to take liberties with color. He freely varies color to explore interpretation, often deriving different moods from the same subject reference. Color literally seen may be cooled, faded, deepened, or intensified to portray the artist's emotional spin on the subject.

A photograph taken in Cordoba, Italy, and paintings inspired by the scene exemplify what Lynch enjoys most—"to create something dramatic from an ordinary scene." A series of workshop demonstrations serve as light, color, and compositional tests. In his *Italian Shadows* demonstration paintings, color expresses the light. In the first demonstration, the upper half of the building exhibits what he describes as "a glow of light with just a few accents of light filtering onto the street." In the second demonstration, he plays down indications of buildings and figures, since they are potential distractions to the interest in light. As he explains, "An explosion of bright warm color emphasizes how I want the viewer to *feel*, not just *see*, the sunset."

Tom Lynch. Photograph reference: Cordoba, Italy. 2003

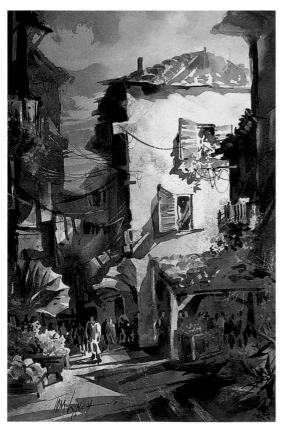

Tom Lynch. *Italian Shadows Workshop, Demo 1.* 2004. Watercolor on paper, 21 × 14" (53.3 × 35.6 cm)

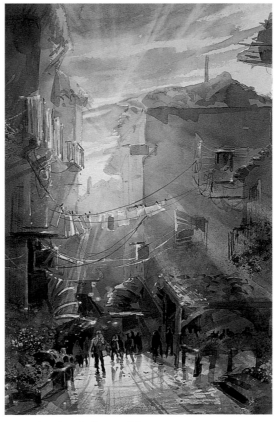

Tom Lynch. *Italian Shadows Workshop, Demo 2.* 2004. Watercolor on paper, 21 × 14" (53.3 × 35.6 cm)

"To showcase a dramatic path of light," Lynch took a different approach in a subsequent pair of paintings by exaggerating color differences and reversing their use. The first demonstration painting is warm-color dominant with cool colors near the impact area. The second painting is cool-color dominant while warm colors accentuate the impact area. Lynch elaborates on his approach, "The more I push for creativity the less true color comes into play. Variety in clean, fresh color changes has become most important in my work."

Tom Lynch. *Cordoba Workshop, Demo 1*. 2003. Watercolor on paper, 14 × 21" (35.6 x 53.3 cm)

A warm dominant/cool impact demonstration

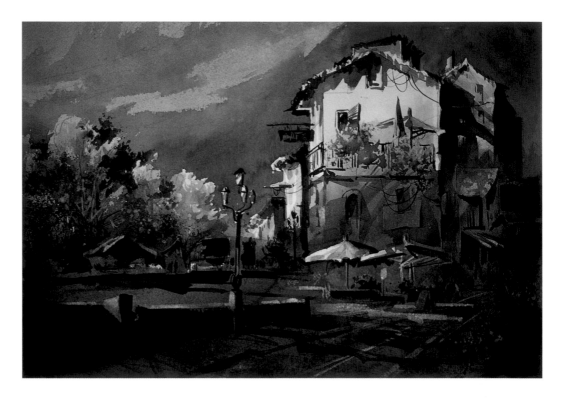

Tom Lynch. *Cordoba Workshop, Demo 2*. 2003. Watercolor on paper, 14 × 21" (35.6 x 53.3 cm)

A cool dominant/warm impact demonstration

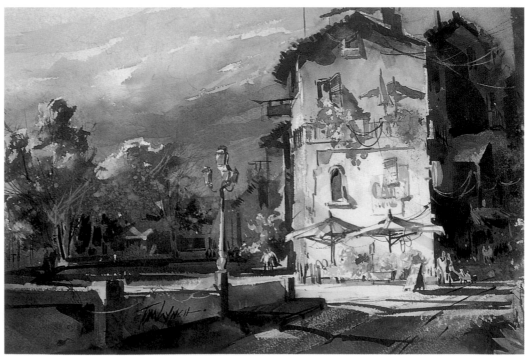

Lynch's *Kingsmill Country Club* provides another example of how the artist uses color to improve upon a photograph reference. A veteran painter of many golf course scenes, Lynch's challenge is "always to distract the viewer from the game in order to enjoy the landscape." Emphasis on autumn color intensity and increased tree proportions in the middle ground add needed visual interest. From sky to grass, and the exaggerated cart path, colors are enriched, prompting viewers' minds to wonder off the course.

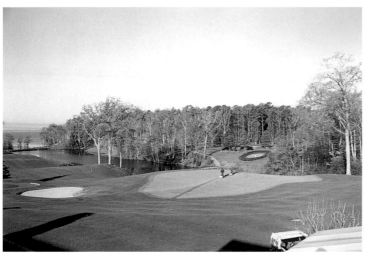

Tom Lynch. Photograph reference: Kingsmill Country Club. 2003

COLOR CONCLUSIONS

Tom Lynch's color use stems from imagination rather than from techniques for realism. In his workshops, students are barraged with creative watercolor wash and splatter "tricks" for a wide range of subject interpretation. Built on years of experience and experimentation, Lynch's technical repertoire supports spontaneity in his paintings. Personal expression guides application. In closing, the artist offers a favorite quote from marine painter Charles Vickery: "Artists are paid for their vision, not their observation."

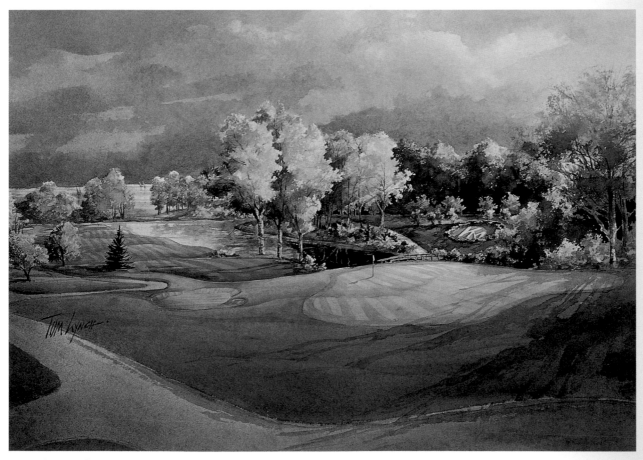

Tom Lynch. *Kingsmill Country Club*. 2003. Watercolor on paper, 22 × 30" (55.9 × 76.2 cm)
Collection of Kingsmill Resort and Conference Center, Williamsburg, Virginia

IN THE STUDIO: KITTY WALLIS

COLOR PREMISE

Kitty Wallis states that she is "engaged primarily in mastering color perceptions and expressive skills." On finding her way with color, the artist reflects: "The idea that light is what we see when we view the world, not the thing itself, rang like a bell. All our visual perceptions are light. When we look at our paintings we see light. All our visual art experiences, from the most shallow to the deepest epiphanies, have been passed into our bodies and brains on waves of light.

Once we see this simple idea, obvious and mysterious, we can relate it to our struggles and growth as we learn more with each painting. What is the sensation we see? How do we know when our brain is being beguiled by misty air, dazzled by ratcheting glare, seeing the color of air in the shadows, thrown up and down by bouncing light? We must look for the colors, values, and juxtapositions that convey these perceptions to our waiting brain cells. Color is a tool we can use to mold, push, and fracture the waves of light coming from our paintings to carry our expression and perception of a scene into our viewers' brains."

For Kitty Wallis, methods directly align with both perception and expression. She develops her works, often portraits, in three phases, each involving a different medium. Starting on paper, usually a 22-x-28-inch sheet of Ersta paper, Wallis first marks minimal charcoal lines to establish compositional "bones." Then, to "express essential planes and subject character," she applies a color underpainting in simple washes with diluted Createx Pure Pigment, a vibrantly colored pure pigment packaged in a liquid water-based solution. In her next and final stage, she makes marks in pastels.

STUDIO PRACTICE

Kitty Wallis describes her techniques as being derived from what she calls a "dialogue with my brain." Her approach is shared with a proviso to others: "Don't paste formulaic techniques on the window between you and your brain; this will falsely give you the idea that you have discovered a solution." Wallis hopes that others will relate to aspects of her techniques, but cautions, "Find your own language. I'm still learning mine."

Wallis credits Nicholas Carone, her first art school drawing instructor, with having taught her the "surveying technique." She recalls, "He taught many ways of perceiving what we see. One was the art of looking for the 'bones' of the painting—the verticals, horizontals, and angles of the subject—while relating these elements to our internal sense of gravity. This is basic to composition and to producing space, movement, and expression. I learned how to bring my bodily responses onto the paper as I looked at the subject. Having developed this skill, I could begin to funnel my senses and feelings into my line and eventually into my color expression."

Wallis uses the surveying technique during the initial charcoal phase during which she positions her subject on paper. She describes how she applies the technique in her work: "I begin with a map of the territory using thin vine charcoal sparingly, since it does not form a resist under the pastel. As I conduct my survey I mark with small dots, dashes, angles, and lines, avoiding my tendency to draw pleasing lines too early in the process.

I am looking for subject placement and composition first, then the movement (or vice versa), and then an anchor—the last being a visual point I feel I can commit to and to which I can relate the rest of the painting. I am willing to change any of it, even the anchor, as I learn more about the subject. By keeping the drawing fluid as long as possible, I can incorporate my heightening awareness into the painting as I study the subject.

I stay in the overview mode throughout the early stages of the painting, first with charcoal, then with my underpainting color, then with pastel. I hold the drawing open, not making any permanent decisions, until the composition

'clicks'. I had to learn to avoid going directly to the sensual quality I enjoy so much in my lines in order to keep the drawing fluid and open to change, until I have been around the painting a few times. Otherwise, I would create little precious moments I would be loath to change."

The artist aims to "set the bar for the whole painting" by relating the underpainting to her charcoal-marked 'bones'. Wallis sought a medium that would produce "effortless, pigment-loaded color washes without filling in the paper's tooth." Her search ended with Createx Pure Pigment, which Wallis feels "produces the perfect underpainting medium for my paper and my pastel strokes." She describes her pastel strokes as "opaque marks that require strong colors in the underpainting, and usually do not work with diaphanous, subtle veils of wash."

ARTIST'S PALETTE

As of this writing, Kitty Wallis's favorite palette consists of warm and cool versions of each primary: Hansa Primrose and Diarylride Yellow, Phthalo Blue Green Shade and Ultramarine Blue, Naphthol Red Light and Quinacridone Magenta. She typically starts her underpaintings using a choice of three to six colors from her split-primary palette. Wallis credits Michael Wilcox's book *Blue and Yellow Don't Make Green* with changing her thinking about mixing color.

Wallis describes her underpainting process: "I want mine to be an informative beginning, a study of the subject. I do not use an all-over tone, a practice that I find to be a hurdle to overcome rather than a prompt to a higher level. I make an underpainting that dissects the color, builds composition, and begins to characterize movement.

I paint the underpainting as a printer makes a print, one color at a time over the whole painting. Starting with yellow, I read the pattern of yellow in the subject. I paint it where I see it, in various strengths and directions of brush strokes, pure yellow, the different strengths of yellow in the green, orange, brown, a thin veil of yellow in the mauve, etc. I dissect the color, reading the values and building the movement and mass of the forms. Next I use either red or blue, depending on the feel of the painting and subject, finishing with the last color. I mix secondary and tertiary colors on the paper as I overlay the primaries, giving me information about my subject and the colors I see. After it dries, squinting helps to check the underpainting for correct value structure."

Wallis produced a series of on-site works, in pastels over watercolor, while on trips to Claude Monet's Giverny estate. She recorded

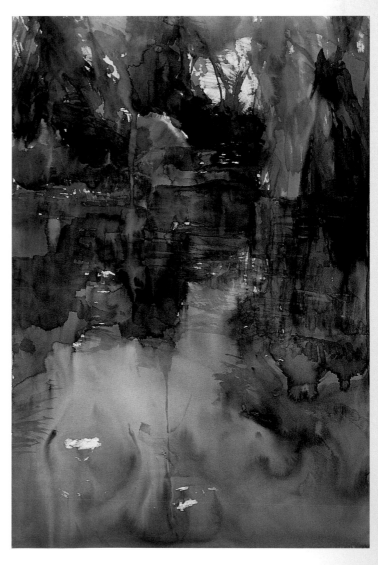

Kitty Wallis.
Giverny Afternoon,
underpainting. 1990.
Watercolor on Wallis
paper, 36 × 24"
(91.4 × 61 cm)
Collection of the artist

her initial observations with abstract water-color shapes similar to the pigment dispersion underpaintings characteristic of her current work. The underlying colors show through between pastel marks subsequently applied to develop detail.

Wallis mixes, rolls, and markets her own line of pastels. She describes mixing her own colors as a way of "building my color voice, incorporating into my colors the experiences and insights I have gathered as I work through the years." She refers to her initial pastel application as "the ugly stage." Describing the pastel stage, she says: "I match my available pastel colors to the partially established palette, based on the correctness, problems, and revelations of my underpainting. I make marks here and there, finding the colors, continuing the drawing and correcting the underpainting. I collect my palette of pastels. To produce an authentic color experience for the viewer I must transpose the palette of the subject to relate the under-painting palette with my pastels, while maintaining a consistent color relationship throughout the work.

Color values, strengths, and temperatures relate to subject structure and to spatial atmosphere. Larger shapes, knitted with color relationships from smaller ones, govern the composition.

I found my technique through searching for things that work and for strategies that take me, sometimes into the 'zone'. These techniques are scaffolding for my painting. If all these techniques and tests go well, my painting-self can come out and play in confi-dent joyous freedom."

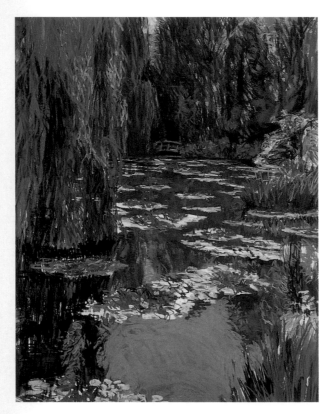

Kitty Wallis. *July 12th.* 1990. Pastel on Wallis paper with watercolor underpainting, 36 × 24" (91.4 × 61 cm)
Private collection

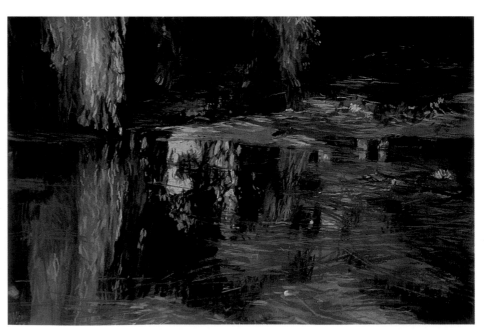

Kitty Wallis. *Later Afternoon.* 1986. Pastel on Wallis paper with watercolor underpainting, 22 × 30" (55.9 × 76.2 cm)
Private collection

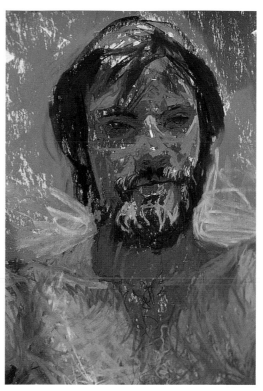

FAR LEFT: Her portrait of Chris was done as a demonstration following an excursion with her students to an exhibition of Fauvist art. In a class afterward, she devised an exercise for them to re-experience and appreciate color use they saw in the exhibit. To force a Fauvist look, students were prompted to make strong strokes from a limited palette of bright colors, leaving mixing in the minds of viewers.

LEFT: Wallis illustrates the importance of temperature differences in her portrait of Steve. Its background contains warm green, but no warmer colors. In another context, shadows under the eyes and below the chin might look warm. Compared to the skin's orange-red dominance, red-violet shadows read as cool. Note the use of strong black/white contrasts on the head.

Kitty Wallis. *Chris*, detail. 1974. Pastel on sandpaper, 24 x 16" (61 x 40.6 cm)
Collection of the artist

Kitty Wallis. *Steve*. 1978. Pastel on sandpaper, 28 × 22" (71.1 × 55.9 cm)
Collection of the artist

COLOR CONCLUSIONS

"Perception is key to individual color expression, yet most of us hinder ourselves by failing to listen to our feedback systems," acknowledges Kitty Wallis. "But," she grants, "it's not easy to learn to pay attention to what our eyes and brain are telling us. It becomes more possible when we realize that many kinds of information make up what we see. When we apprehend the elements of color information, they can be used in our work to make it more effective."

When observing an interesting light effect in the environment, Wallis proposes questioning, "How does the color and light tell you what you are seeing? Is the light strong or weak, warm or cool? Is it clear or foggy? How can you tell? What is it doing to your eyes? How are the forms and colors distorted by light? Are fugitive colors manufactured by your eyes as you stare at it?" She suggests analysis of observations by considering, "What is your reaction? Do you look at colors to see what they are or try to 'see around them' to what is 'really there'? Look for the clues our eyes give us. We know what we are looking at without walking over to touch it. For example, how do we know we are looking at water?"

Summing up, Wallis states that the artist's expression of "light and life" is in the "handling of color effects." Avoiding formalistic thinking, Wallis relates, "Color is not a clinical scientific idea accurately described by rules and formulas. It's a powerfully poetic, simple understanding of what we usually ignore. We *can* learn to watch our brains communicating with our senses. Unless we allow ourselves to learn our own sensorial language and become articulate in it we cannot produce authentic work in color."

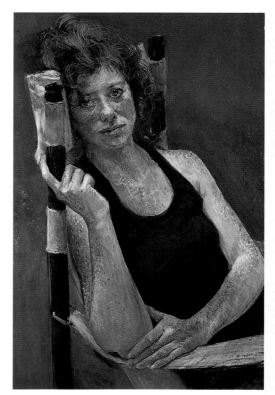

While the scale of her strokes is reduced in *Dancer*, the range of their hues is broad. Some reflect the red surroundings, others the dancer's dark blue attire. Colors collectively express the artist's communication with and interpretation of her subject.

Kitty Wallis. *Dancer*. 1975. Pastel on sandpaper, 28 × 22" (71.1 × 55.9 cm)
Collection of the artist

olor media in all manner of content and form tempts artists of every level. The sampling of familiar liquid- and solid-media options reviewed in this chapter demonstrates different qualities of media, though it does not account for the incredibly broad range of color art materials available today. Artists are constantly challenged to rethink color choices, both by centuries of shifting color theory and ever-expanding color options. Age-old processes like fresco, tempera, and encaustic are still used, yet manufacturers continue to develop new media and create variations of existing ones.

Artists are often unaware of the lengths to which manufacturers go in making art materials. Compared to artists' handmade paint batches of ages

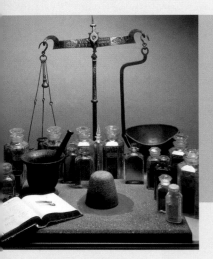

Winsor & Newton historical paint-making materials

CHAPTER TWO
MEDIA MÉLANGE

past, today's art materials must meet demanding industry standards, requiring extensive testing and monitoring that keep pace with the most current research and technology.

The quality of any color media, which is an ongoing concern for artists, depends on content and manufacturing. The quality of media varies widely, but it is always reflected in how art materials are priced. Ultimately, cutting costs, especially on color, can be at the artwork's expense. Artists who want their works to live on beyond themselves should avoid cutting costs on color.

COLOR CONCOCTIONS

THOUSANDS OF YEARS AGO, Cro-Magnon cave painters used what today might be called a "limited palette." They made the most of what they could find around them—reds, yellows, and browns made from earth, carbon black, berries, blood, chalk, and soot. Such crude beginnings prompted an unquenchable desire for more and better colors.

Earth colors continue as palette mainstays, partly due to availability. Iron-oxide compounds for siennas, ochres, and umbers, along with carbon darks and calcium lights account for the prevalence of earth tones in old masters' artworks. Colorful pigments were scarce and, unlike lightfast earth colors, their stability was suspect.

Some colors were prized for their beauty and rarity. Limited, inaccessible resources and difficult processing inflated value. For example, during antiquity, the color purple (referred to by color theorists as "violet") took thousands of crushed shellfish to make enough purple dye for one yard of fabric. Laws reserved purple for trim on the tunics of senators and generals and for emperors' robes.

Certain popular colors of old had to be abandoned because of harmful content. Often referred to as "Chinese Red," Vermilion, the best red of its day, originated in second-century China from sulfur and cinnabar, a red powder of ground raw mercury ore. Corroded white lead reacting with vinegar was the basis for making Flake White, the oldest of white paints, which was the standard until its deadliness was realized.

To meet the growing demand for color, chemistry revolutionized paint manufacturing by introducing compounds not found in nature. Invented by accident, Prussian Blue was the first of many synthetic colors to emerge in the eighteenth century.

Chemists discovered that dyes could be converted into pigments. Dyes tend to fade (they go into solution with the medium and bleed into surrounding materials), but pigments can be lightfast (their structure holds when ground into suspension with medium). As a result paint adheres yet remains separate from a surface. The first color to undergo a dye-to-pigment conversion—Rose Madder Genuine—came out in 1806; the second color—Alizarin Crimson, ground from madder root—in 1868. Long an unstable red, manufacturers now produce lightfast versions of Alizarin Crimson. *Lake colors* are the result of dye fixed to inert pigment or *lake base*. Crimson Lake, for example, is a matching color alternative for Alizarin Crimson. Twentieth-century synthetics could be dye or pigment, or both.

Chemical imitations replaced many poisonous or expensive pigments, improving color availability, safety, and affordability. In 1828 a French chemist created a less expensive alternative using a synthetic compound for Ultramarine Blue identical to lapis lazuli's molecular structure.

Metal by-products of the Industrial Revolution provided an inorganic source for colors made by heating compounds to extremely high temperatures. The Impressionists popularized new cobalt, cadmium, and manganese colors despite high costs driven by materials and manufacturing. On twentieth-century palettes Cadmium Red replaced Vermilion. Cerulean Blue was introduced in 1860.

Late-nineteenth-century experiments with carbon-based compounds launched a generation of colors characterized by brilliance, lightfastness, transparency, and greater luminosity—Hansa Yellow and Aureolin among them. Chemists created iron oxide alternatives for natural earth colors. Zinc White, a cooler white made from zinc oxide, offered a less opaque yet non-darkening substitute for Flake White. Titanium White, from titanium dioxide, became the new white standard, favored for its opacity and tinting strength. Manufacturers now grind zinc with titanium to make a more permanent white film. Technological color advancements for use in other industries—such as automotive manufacturing and fashion—continue to benefit the art world.

MANUFACTURING MAKEOVERS

PAINTS, once made manually for immediate use, are now mass-produced, packaged, and stored. Long life on a support has always been a principal goal for artists' colors. Contemporary paints are additionally expected to hold up for long periods before use. Once in use they must perform consistently. Consequently, paint content and method of manufacture, once simple, are today more advanced and more complex.

EARLY COLORMEN

In the West, first the Catholic Church and later rich patrons increased demand for art along with better methods and materials. During the Middle Ages, a studio system with apprenticeships evolved wherein producing paint became a professional skill. If they did not grind their own, artists obtained paints from professional colormen who also served household and theater paint markets. The highly skilled craft of making paint required patience, muscle, knowledge of pigments, and often a friendly relationship with the local apothecary. A hand muller, originally a mounded flat-bottom stone, was fundamental. By sliding it in swirls over a larger flat stone, pigment substances were ground with oil into workable paint, commonly stored in recycled animal bladders.

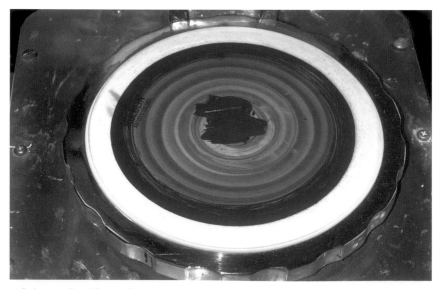

Mulled paint collected from mulling plate.

MILLING

Standing on generations of manual trial and error, current color media production takes place in high-tech factories. Mill manufacturing refers to the whole process of making color media, which mainly consists of grinding pigment with a medium on big metal rollers that replaced hand mullers. Milling paints, even in small amounts for preliminary testing, involves mechanical precision. Today's controlled production insures consistency, unlike the unique color batches produced by hand mulling. While some steps are common to all color media, procedures vary according to medium and pigment.

Preliminary blending of all paint ingredients is essential to proper grinding. Premixed solutions are not suitable for artists' use because pigment is not yet properly suspended in medium. Initial consistency varies from slurry to paste according to each paint type's required pigment-to-medium ratio. In order to meet workable standards other agents may be required to compensate for differences in pigment character. Resin and siccative (a drying agent) often supplement oil paints. Surfactant, fungicide, and antiseptic ingredients may be added to watercolors. Some gouache colors need an additive to create expected opacity.

Colors are expected to exhibit qualities true to their nature. The extent of milling directly affects color quality. A pigment cleaned of impurities produces color of greater hue accuracy and chroma strength. On the other hand, inconsistencies in processing tend to produce performance problems—such as paints whose oil and pigment separate out of the tube, vary in viscosity, and spread or dry unevenly. They can be too gooey or too stiff to easily squeeze from a tube and require thinning before mixing. In time, they may crack, bubble, or flake off. Well-milled paint delivers color and performance consistency in a durable stable paint film (the emulsion formed by paint adhering to canvas or another support).

The Viridian sequence illustrates the importance of thorough grinding, which may be repeated three to six times to achieve preset standards. According to color chemists at Holbein Works, Japan, individual colors often gain clarity and beauty when properly ground. For example, Phthalocyanine Blue tends to be "greenish and dark blue and slight violet under insufficient grinding, but transfers to clear sky blue if fully ground." Insufficient grinding accounts for differences in color appearance between brands.

CLOSE-UP 1. Premixed Viridian has a very rough matte surface like sandpaper. The hue is dull.

CLOSE-UP 2. After grinding by a roll mill, Viridian pigments are insufficiently dispersed. The surface is still matte and the hue less dull.

CLOSE-UP 3. With more grinding, Viridian hue looks more natural but the surface is still matte.

CLOSE-UP 4. With additional grinding, Viridian hue becomes more natural and deeper. The surface becomes slightly transparent and slightly glossy.

CLOSE-UP 5. Viridian hue improves with more grinding and its surface gains transparency and gloss.

CLOSE-UP 6. A final grinding brings Viridian to a clear, deep, and beautiful optimum level with transparency and gloss similar to organic colors.

COLOR CARRIERS

Artists' colors consist of pigment suspended in a substance—alternately called a *binder*, *medium*, or *vehicle*—needed to wet each pigment particle during milling and to enable them to be evenly spread on a support. Pigment-to-binder ratio is critical to paints' appearance, performance, adherence, and stability. The term *medium* has other uses regarding color materials. A *medium* is also an *extender* added before or during application to increase paint quantity while maintaining viscosity. And, in the broadest sense, *medium* is used to refer to the category of a work of art indicated by materials—for example, painting, drawing, or sculpture. Though the plural form *media* is used when referring to more than one category of art materials, the plural *mediums* is commonly used to refer to multiple extenders, binders, and the like.

Water, though an obvious option for moving color across a surface, has not proven effective for holding pigment in consistent suspension. Advancing from human saliva—perhaps the first medium, used by prehistoric cave artists—many naturally gooey, sticky, adhesive substances have been tried. Egg, honey, curdled milk, gum, glues, wax, plant oils, varnishes, and resins still serve as color binders alongside modern synthetic alternatives.

Traditional oil paint's slow drying time has often raised objections. Late-twentieth-century manufacturers responded with *alkyd*, an oil-modified resin incorporating alcohol and chemically polymerized acid. Though alkyd increases transparency and strengthens paint film, it is generally preferred as an extender medium for traditional oils since it does not bond to pigment quite as well as linseed oil and cannot hold a comparable high pigment load. At the expense of the buttery consistency for which traditional oils are often preferred, alkyd speeds drying time and, unlike historically used driers, does not cause darkening or cracking.

Precisely formulated portions of Cadmium Red pigment and an alkyd-resin vehicle are measured and weighed before introducing them to a Hoover muller.

Beyond determining the various forms (liquid or solid) color media take and their solvents, the medium in which the pigment is suspended affects application methods and color appearance. Many mediums are packaged separately, allowing artists to alter paint consistency while working. For example, poppy seed and linseed oil—both of which can be a binder or extender—have unique consistencies and performance characteristics that can slow or speed drying, increase transparency, and alter paint viscosity or its surface. Some mediums may be combined with other materials like varnish and turpentine, formulated for a multitude of application techniques.

PIGMENT PERCENTAGE

While pigment is not the only ingredient in color media, it is undeniably the most significant. Color brilliance—the *chroma* factor—relies on pigment quantity and quality. Greater pigment content generally results in stronger color, or higher *saturation*. With too little pigment, paint loses brightness and coverage. However, there are limits to pigment content: Paint with too much pigment becomes unstable and is liable to flake or crack. Pigment saturation is also limited by the need for performance optimizing additives. Just as we have come to expect preservatives in packaged foods, we realize that paints in tubes cannot be sustained for years without certain additives. Since pigment is the most expensive component of color media, it follows that cheaper paint prices generally indicate less pigment.

A higher percentage of pigment will also improve tinting strength—the degree to which a color influences mixing results (also called *staining power*). Notwithstanding their percentage in a medium, pigments have different intrinsic abilities to overpower other colors in mixtures. They also differ in the amount of white paint required to lighten them. Phthalocyanine Blue, a modern replacement for Prussian Blue, is a good example. Phthalocyanine Blue and Green have tinting strengths far greater than most

colors and quickly dominate in mixtures. To equalize their influence on the color of the mix when combined with other pigments, manufacturers often reduce "phthalo" (short for phthalocyanine) colors with an extender.

> **Color is a power, which directly influences the soul. Color is the keyboard, the eyes are the hammers, the soul is the piano strings. The artist is the hand, which plays, touching one key or another, to cause vibrations in the soul.**
>
> VASSILY KANDINSKY (1866–1944)

TESTING

High quality paint comes out of the tube smoothly, matches the viscosity of other same-make colors, and covers, mixes, and spreads evenly. It dries properly and endures with a finished look (glossy, matte, and so on) appropriate to its medium. It sticks and stays. Its maximum pigment-strength color is consistently accurate and lightfast. Paints should also be relatively safe to use when properly handled. Its qualities should remain constant, whether stored in a tube or jar. Manufacturers monitor all performance aspects through extensive testing beyond what the human eye is capable of observing or memorizing. Processed paints must pass all levels of hue, dispersion, viscosity, appearance, coverage, lightfastness, and stability examination before they are allowed to fill retail containers.

HUE If an artist has a favorite color and buys another tube, its contents are expected to match previous ones of the same make. Paint manufacturers use CIELab or Munsell Color Notation systems for specifying color accuracy, as do many other industries.

DISPERSION The degree of grinding affects color particle size and paint consistency. Graphic depictions assist chemists in adjusting pigment-to-vehicle ratios or spot the need for additional grinding.

VISCOSITY Viscosity ratings measure *thixotrophy* (the ability to maintain consistency whether in the tube or in use) and *rheology* (flow). *Long rheology*, a less desirable stringy or ropy quality, is more typical of resin-based paints. In oil and acrylic paints, which should be dense enough to be applied thickly without dripping, *short rheology* is preferred for a smooth flow. Viscosity affects covering strength and, therefore, how dark or light colors appear.

MASSTONE AND UNDERTONE Application density affects color appearance. *Masstone* (thick undiluted application) and *undertone* (very thin layer) must match set standards. Appearances depend upon each color's character (opaque and thick or transparent and thin). Artists need to know what to expect from a thick or thin color application, whether they want to cover a color already applied or intend for a bottom color to show through color applied over it.

APPEARANCE Expectations for appearance vary among media and pigments. For example, casein paints have a matte finish compared to typically lustrous oils, while acrylics tend to have a satin appearance. Wet-look colors exhibit greater intensity.

LIGHTFASTNESS With respect to the life expectancy of works, little concerns the art world more than the durability of color used in their creation. The effects of the sun and simulated light exposure can be measured (see light booth below). Pigments able to retain molecular integrity under extensive light exposure are considered *lightfast*. Those that quickly lose color in light exposure are considered *fugitive*. Fading is caused by damage to molecular structure from years of light energy bombardment. Once its structural integrity is altered, a color's reflection/absorption ratio also changes, producing a visible color shift.

STABILITY Paints may be tested for adhesion, physical, thermal, and antibacterial stability. Even a very small quantity of moisture in oil paint disturbs the proper reaction of oil and air. Both oil and aqueous colors in the tube are tested for stability under heat-prompted conditions.

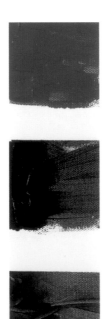

MASSTONE VERSUS UNDERTONE. Three different green Holbein Artists' oil colors are compared. Opaque-rated Cadmium Green (top) looks the same spread thick or thin. Transparent Sap Green (center) and semitransparent Viridian (bottom) both look quite different spread thick and thin. White gesso ground shows through thin applications. Thickly applied colors cover the white. Opaque colors look brighter spread thickly compared to transparent and semitransparent colors. Transparent color masstones may look darker than expected. When spread thinly over a white surface, the resulting transparency reveals their colors.

LIGHT BOOTH. The controlled and measured exposure includes various light sources, for example, ultraviolet light, simulated daylight, and fluorescent light.

LABEL LANGUAGE

LABELS ON TODAY'S art materials offer much more information than in past generations. Within set standards, manufacturers' labeling practices vary. Colors by the same name but from different brands may be formulated differently. However, the same health and safety disclosure laws apply to all. Today proper labels on artists' materials and their supplemental brochures provide their color name, pigment content, opacity and permanence rating, drying time, chemical source, as well as health and safety notifications. Learning to decode labels can lead to better color media choices.

HEALTH AND SAFETY

ASTM International (www.astm.org), formerly the American Society for Testing and Materials, is now a global-standards development organization. Its U.S. subcommittee on Artists' Paints and Related Materials comprises art industry stakeholders (artists, manufacturers, educators, toxicologists and other scientists). By consensus, its five thousand members write standards for quality, testing, and disclosure. Art manufacturers are not required to participate in setting standards. Compliance with standards, except for ASTM D 4236, is also voluntary, although most do comply.

In order to be sold in the United States, by law, all art material labeling must identify toxins and appropriate warnings. "Conforms to ASTM D 4236" (adopted in 1983 to address chronic hazards in art materials) must be printed, following required periodic toxicological evaluation. Since 1940 the Art & Creative Materials Institute, Inc. (ACMI) has been overseeing the safety of art, craft, and other creative materials. Its various seals certify the need and content of label cautions.

ACMI represents the highest standards in art manufacturing. A self-monitoring organization, it certifies only materials submitted to rigorous testing that has proven more stringent than nationally regulated testing. Though ACMI's logo is not printed on art media labels, it does appear in manufacturers' brochures.

Conforms to ASTM D 4236

Conforms to ASTM D 4236

A product bearing the ACMI Health Label seal has been evaluated and is properly labeled as either nontoxic without warnings or with warnings if contents may present an adverse effect. (Phased out on or before 1-1-04 as a hazard warning seal in favor of the new CL seal and on or before 1-1-09 on nontoxic products in favor of the new AP seal.)

New ACMI seals: "AP" indicates nontoxic content; "CL" (cautionary label) indicates potentially toxic content

ACMI- and ASTM-labeled Cadmium Red. In accordance with health standards, appropriate warnings and conditions are stated.

COLOR STABILITY

ASTM standards mandate color lightfast ratings for artist-grade colors in most media. (Note: There are not quality standards for all types of art materials. As of this writing, for example, pastel standards are under development at ASTM.) Stability is rated on a scale of 1 to 5: category I (excellent) pigments maintain relative resistance to change under testing conditions; category II (very good) colors change negligibly yet are still considered quite resilient. Multiple pigment colors are rated according to the pigment with the poorest performance.

STUDENT GRADE VERSUS ARTIST GRADE

Art materials are produced for specific consumer groups, with price being the most obvious indicator of quality. Some are manufactured with a low cost objective, others demand high standards regardless of cost. "Student Grade" indicates lower price and quality. In the youth market, colorful gimmicky packaging is often more important than content. Paints quickly milled use less or cheaper pigment with more extenders. Lower grades offer basic sets with all colors at the same economy price. When shopping for low-priced grades, low expectations for colorfastness, brilliance, and performance should follow.

The highest expectations, and highest prices, apply to color media marketed as "Artist Grade." They offer ideal working properties, genuine pigments free of impurities, excellent tinting strength, true color formulation, strong chroma, minimal additives, the best possible lightfast ratings, and are available in broad spectral and value ranges. Rather than recipes for familiar wheel colors—red, blue, yellow, green, orange, and violet—artists' colors are made from a single pigment or simple pigment combinations. Ironically, colors whose names sound simple actually have complex color ingredients. Multiple-pigment formulas are part of what makes them "student" grade. Artist-grade colors usually list five or six different price levels determined by pigment and processing. Cadmium Red and Cobalt Blue, for example, are single pigment colors made from cadmium or cobalt metals. Among the brightest and most beautiful of colors, they are also among the most costly.

PIGMENT IDENTIFICATION. The label on a tube of Holbein Artists' Cadmium Red oil paint specifies pigment content as "PR108" (Pigment: Red hue #108 Cadmium Red). The additional "X" symbol indicates potentially harmful ingredients.

Some manufacturers use a more comprehensive "Permanence Rating" of one to four stars, which accounts for ASTM lightfast ratings as well as vehicle stability. Four stars symbolize absolute color permanence, three stars indicate permanent color, two stars signal moderately durable color, and one star applies to nondurable color. Pigments in the two top categories offer confidence under normal interior exposure conditions. The absence of a lightfast rating indicates no evaluation and, therefore, no guarantee of permanence.

PIGMENT CONTENT

Pigments fall under one of two categories: inorganic or organic. Artists may mistake discrepancies in tinting strength, opacity, or coverage for milling faults when explanations often lie in the natural character of pigments. Each individual pigment, and therefore the paint made with it, differs from any other.

Inorganic pigment compounds generally do not contain carbon. They include the oldest pigments, naturally occurring earth colors as well as mineral (cobalt, cadmium, manganese) compound colors developed during the Industrial Revolution. While typically lightfast, opaque, and strong in color, such colors tend to dull quickly in mixing. More modern *organic* pigments are chemical innovations involving carbon compounds, stemming from the twentieth-century fossil fuels industry. They produce typically transparent colors with powerful tinting strength. Many synthetic color versions of either pigment type are available.

Labels identify color in several ways. The sample of the color on the container and name are most obvious indicators. Printed color charts or actual chip samples are usually provided at art supply counters for accurate reference. ASTM standards require matching color appearance to the color named on a label. Identification of actual pigment source or sources is also required, using simple code. The letter "P" (for pigment) is followed by another letter to identify basic hue and ends with a numeric pigment specification. Manufacturers often provide charts that specify color content by their chemical name using a

C.I. (Chemical Index) code. For example, C.I. No. 77202, cadmium sulfo-selenide is listed as the chemical number and name for Holbein's Cadmium Red oil paint.

HUE SKEW

In artists' media, color names, in part, suggest resemblance to basic spectrum colors. Elementary art colors (ideal for practicing basic theory mixing) look like spectrum colors and have simple primary and secondary color names. In the fine-art materials market, where authentic color content is expected, naming and labeling reflect traditions in art history, pigment sources, and sometimes, academic color theory.

Basic hue identification in color naming is a formality for most artists. They come to know, for example, that Viridian is a green and Vermilion is a red. On a paint label, however, the word *hue* signals more than color wheel position; added to the end of a standard color's name, it reveals the absence of genuine color pigment. Hue impostors are economical substitutes created from two or more less costly pigments mixed to look like the original.

Hue versions of the following beautiful but expensive colors are common: Vermilion, Viridian, Cobalt Blue, Cerulean Blue, and Cobalt Violet. Viridian Hue is often made with Chlorinated Copper Phthalocyanine (Color Index PG7, pigment green #7) matched for similarity in appearance and physical properties of lightfastness, tinting strength, and stability. Azo pigment may substitute for Vermilion, Copper Phthalocyanine blue pigment for Cobalt Blue or Cerulean Blue, and Quinacridone pigment for Cobalt Violet Light. Hue formulas vary between makes.

Although it may bear strong resemblance to the original, a hue color cannot provide genuine color replacement. Due to pigment substitutions, mixing with other colors produces somewhat different results. Note in the sample, a comparison of genuine Viridian with the more yellowish Viridian Hue, especially when tinted by white. In masstone, their differences are less noticeable. Compared to a single-pigment genuine color, hue colors—which are

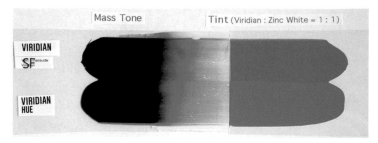

Genuine Viridian (top) compared to Viridian Hue (bottom) in masstone, undertone, and tint

OPACITY SYMBOLS. A solid black-filled circle = strong opacity; an empty circle = strong transparency; a half-black/half-open circle = semiopaque; a circle with a bisecting vertical line = semitransparent paint

already a combination of pigments—tend to be less vibrant and to dull more quickly in mixtures.

OPACITY

Colors naturally differ in density. *Opaque* colors deliver the best coverage, concealing the surface beneath. *Transparent* colors allow for light penetration, permitting the undersurface color to show through. Symbols on labels represent four opacity ratings.

The degree of opacity versus transparency, which varies between media, is further influenced by application thickness. Transparent by nature, watercolors can be made to look opaque if applied thickly enough, though this usually results in a darkening of color. Oils, whose viscosity is characteristically denser than many water-based media, tend to be opaque even though some are relatively transparent. Mineral colors (cadmiums, for example) and traditional inorganic native earth colors (ochres, oxides, and so on) are consistently opaque and *lean*— less oily—in character. Newer colors, utilizing synthetic organic pigments with chemical prefixes, tend toward transparency. Even opaque oil colors can be made to look transparent, if painted thinly with sufficient medium added. Artists become familiar with color opacity variances through experience.

LIQUID AND SOLID COLORS

PAINTS ARE either oil or water based. Traditional oils and watercolors have endured a long history of refinements. Contemporary painting media options, though not yet tested by time, offer some appealing characteristics.

Solid color media consist simply of pigment and binder pressed together in hard form. The medium (typically oil, wax, or gum) must be solid enough to maintain shape, soft enough to apply, and strong enough to adhere.

LIQUID COLORS

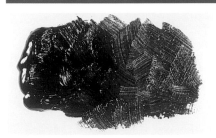

Oil paint. Holbein Artists' Oil Colors, Ultramarine Blue

OILS

Oil paints are extremely versatile, offering permanent, vivid colors that dry hard and still look wet and true to their hue, value, and chroma. Linseed oil, refined from flax seeds, is the most common medium in traditional oil paints. Preferred for its clarity and stability, it is considered the most reliable oil for milling pigments. Linseed oil can take a higher pigment load than other mediums, adding to the paints' brilliance. Substitutes for linseed oil cut costs but not without sacrificing quality. Paint made from less familiar walnut oil is "short" (less flowing) and more apt to darken in time. Safflower and poppy seed oils are alternative mediums that are more commonly used as paint extenders.

Oils dry slowly. Adding more medium increases color transparency but delays drying time. Oils require turpentine or comparable solvents, which are often a drawback. Odorless, nontoxic substitutes for the traditional turpentine solvent are now available.

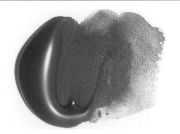

Water-soluble oil paint. Holbein Duo Aqua Oil, Ultramarine Blue (Its appearance is identical to traditional oil color; only in application are subtle variances noticed.)

WATER-SOLUBLE OILS

Manufacturers have cleverly devised a stabilization of two incompatible substances—water and oil. In such an emulsion, each particle of oil and pigment is modified to accept water, providing for cleanup with water instead of turpentine. Water-solubles perform much like traditional oils and may be combined with them. Despite needing to adjust for swifter drying and reduced flow and coverage during application, the end result, with one exception, is indiscernible from standard oil paintings: Colors dry to a matte finish with perhaps a very slight shift in color and must be varnished to revive the wet-color vibrancy of traditional oils.

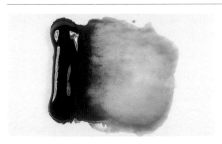

Watercolor paint. Holbein Artists' Water Colors, Ultramarine Blue (Watercolor straight from the tube and undiluted by water looks much darker than when it is applied to white paper.)

WATERCOLOR

Essentially water stained with color, watercolor is milled with a natural, gum arabic binder plus glycerin for moisture. By nature, watercolors are transparent. Consequently, colors quickly lighten with added water. Too much paint reduces light reflection from the white paper base, making colors darker and less bright. But better-grade watercolors, owing to higher pigment content, will maintain strong color when applied heavily or transparently. Colors appear most brilliant when applied to very white paper. A measure of color vibrancy is lost in drying.

ACRYLICS

A twentieth-century industrial plastics phenomenon, acrylic polymer paints became widely popular upon their mid-century arrival. By combining the characteristics of the two most popular painting media—oils and watercolor—acrylics' market appeal was assured. Although water soluble, acrylics share few properties with watercolors, aligning more with oils in viscosity, opacity, and appearance. However, a thin application will resemble watercolor. Unlike luminous oils, acrylics exhibit a "plastic" satin finish. Upon application, pigment particles merge to create a resilient paint film as the water vehicle quickly evaporates. Slight color shifts occur in drying.

Acrylic paint. Holbein "Acryla" Acrylic Polymer Emulsion Artists' Color, Ultramarine Blue

GOUACHE

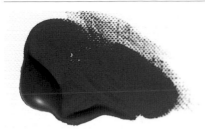

Gouache paint. Holbein Artists' Gouache Color, Ultramarine Blue Light

A centuries-old type of opaque water paint, gouache is made by using a larger percentage of the same gum arabic solutions used in watercolors. It can be mixed with watercolors, but transparency is negated by the addition of inert chalk pigment. Gouache's viscosity produces a discernable paint film coating. Colors dry quickly and with a matte finish. While susceptible to scratching, the dried surface is opaque, resilient, and will not bleed into subsequent paint layering.

CASEIN

Casein paint. Shiva® Signa-Sein Casein Color (manufactured by Jack Richeson & Co., Inc.), Ultramarine Blue

One of the oldest and most durable of paints, casein was used in ancient cultures on at least three continents. Its versatility allows for a variety of transparent or opaque methods. Water-based, casein's binder contains cow's milk curd. Its matte appearance and workability are similar to gouache. Casein stiffens quickly and, once dry, is impervious to water. An effective underpainting for other media, it may be layered repeatedly. According to Ross Merrill, chief conservator at the National Gallery of Art, Washington, DC, "The casein will easily accept oil and will form a mechanical bond."

SOLID COLORS

Soft pastel. Holbein Artists' Soft Pastel Color, Ultramarine Blue

Oil pastel. Holbein Artists' Oil Pastel Color, Ultramarine Blue

PASTELS

Perhaps the most ancient color medium and by far the most popular of solid forms, pastels are often thought of as an alternative to oil painting. Pastels generally contain a higher percentage of pigment than liquid media, and especially so in finer makes.

Soft pastels are the most widely used variety. Their powdery character is visibly apparent, as is their color strength. Although dry-looking, colors can be potentially quite bright. *Oil pastels* of high quality contain wax and mineral oil, which preserve surface and color integrity. Due to their oil content, color vibrancy generally exceeds that of soft pastels. Vegetable oil in lower-grade oil pastels, often in excess and at the expense of pigment, may cause the surface to crack. Excellent coverage is characteristic only of oil pastels with high pigment content.

COLORED PENCIL

Colored pencils are, in essence, wax and pigment encased in wood. They come in all grades and can be easily overlooked as a serious art medium because of the broad market for inexpensive versions. Student-grade pencils, no matter how firmly applied, will not make a bright color due to low pigment content. Artist-grade pencils, with higher pigment ratios, deliver vibrant, durable color. Their superior soft, thick core allows for a smooth lay-down. Colors are easily blended and shaded for an infinite variety of hues. The same color medium used in pencil form is also made into uncased sticks.

Colored Pencil. Prismacolor Thick Core Colored Pencil, Ultramarine
Photograph courtesy of Sanford Prismacolor

Colored Stick. Prismacolor Art Stix, Ultramarine
Photograph courtesy of Sanford Prismacolor

IN THE STUDIO: BILL JAMES

ABOUT THE ARTIST

Bill James is a member of four national art associations including the Pastel Society of America (which has awarded him the title of Master Pastelist), the American Watercolor Society, the National Watercolor Society, and the Knickerbocker Artists. He has won many awards from them as well as from regional shows, including sixteen Best in Show awards.

James's work has been published in several national periodicals—among them *The Artist's Magazine, American Artist, The Pastel Journal, Watercolor Magic,* and *International Artist.* He also appears in numerous books, including the Splash series, *The Best of Pastel, The Best of Watercolor,* and *The Best of Portrait Painting.* He lives and works from his home and studio in

COLOR PREMISE

Bill James wants his viewers to feel something. In any medium, his paintings tell a story, create a mood, and evoke emotion. While facial expressions help to convey emotion in his figurative works, James uses color to impart a message in all of his paintings.

In landscapes, color is his primary means for expressing time of day, weather conditions, and season. Rather than rely on linear perspective, James tends to indicate depth and space with color. Patterns of forms and colors are emphasized over composition. He finds that "by inflections of brushwork (or strokes of pastel) and gradations of color, depth can be defined with a form of aerial perspective." Additionally, he may "overlap successive planes and diminish detail on distant objects to indicate space and distance."

James likes to experiment with unusual combinations of colors, especially those different from what might be expected for a certain subject. He prefers complementary color combinations for their ability "to add vitality and strength to a painting." James observes that when opposite colors are placed side by side, "The subject literally jumps off the surface." He might also change the elements in a painting to see how other colors will work.

The artist acknowledges a tendency for very bright color, which he attributes to his early experience as an illustrator. Over the years, James's colors and application techniques have evolved. He recalls, "With illustration, reproduction required bright colors, which all seemed a little cartoon-like." Now, as a fine artist, James's color treatment is more refined. Still bright at times, his colors have become more "controlled." He now incorporates earth tones, "colors which are more subtle, to make the scene more realistic and believable."

James claims influence from Claude Monet and Wolf Kahn. He describes Monet's theory as "painting objects the way you like to see them instead of how they really are." James describes Kahn's imaginative color schemes as reminiscent of Monet.

COLOR METHOD

Before painting, Bill James places colors in front of him for easy access. Generally, the artist first observes everything in a scene (figurative or landscape) and then assigns an overall color for each element. He adds colors with the same hue and tone to be used with each main color to "contrast one color with another to give each more intensity." He explains, "Contrasts of complementary colors divide colors into many closely related but varied tones." His favorite pairings include Yellow Orange and Pink with Ultramarine Blue and Viridian.

As painting begins, James applies pastel strokes "side by side or one on top of another in a loose manner"—a technique he considers "Impressionistic and spontaneous, and at the same time, very accurate." The artist uses two different techniques—*glazing* (applying one color "transparently" over another so that the bottom color shows through the top color) and *scumbling* (opaque color application, concealing what lies beneath)—to achieve a desired effect.

Concern for depth is a constant in his work. He uses strong, loose, warm color strokes to represent foreground objects. In backgrounds, characteristically devoid of detail, he blends lighter colored strokes to create a feeling of distance. James concentrates more on color than on memory of details. The result, contends James, is "surface effects that, at times, become decorative more than descriptive."

STUDIO PRACTICE

Whether in pastels, oils, or gouache, Bill James's paintings exhibit common color character. He finds that pastels best satisfy his "goals as a fine artist." Working with pastel, he can "combine the effects of color, line, and tone, in a single process to create a successful painting."

In his pastel *Fall on Back Road* James reveals his color approach. It exemplifies his propensity for using color to make landscapes more interesting than in reality. He recalls, "Originally, it was an overcast fall day, so the colors I saw were monochromatic browns, grays, with a little olive. I changed the color of the tree in the middle to a bright yellow, and the mountain in the background to a complementary blue. Therefore, depth was created by the use of color instead of line. Heightening colors throughout contributed to converting a scene full of somber colors into a much more exciting landscape."

ARTIST'S PALETTE

The artist describes his pastel palette as "never the same" and his colors as "too many." Color selection is dictated by subject matter. His approach involves hard pastels from Holbein and Rembrandt for initial drawing and placement. Once final rendering begins, Bill James switches to softer pastels made by Sennelier, Schmincke, or Unison. His color range is similar in any painting media.

James's oil paint palette includes Winsor & Newton, Rembrandt, Daler-Rowney, and Grumbacher brands. His most-used oil colors include: Green Gold, Permanent Red Light, Phthalo Green, Raw Umber, Permanent Yellow Green, French Ultramarine, Manganese Blue, Cobalt Blue, Cadmium Yellow, Cadmium Barium Orange, Permanent Red Medium, Permanent Green Light, Chromium Oxide Green, Cobalt Violet, Dioxazine Purple, Indanthrone Blue, Raw Sienna, Yellow Ochre, Viridian, Green Earth, Sap Green, Van Dyke Brown, Burnt Sienna Deep, and Titanium White.

For water media, James coats white gesso over illustration board or hot-press watercolor paper. He sets out a limited number of colors around a porcelain tray, leaving the center open for mixing additional colors. He uses Winsor & Newton Designers Gouache and Da Vinci Gouache brands applied in transparent washes.

Near the inside edge of his palette, James arranges gouache colors, from left to right, starting at the bottom: Van Dyke Brown, Chinese Orange, Yellow Ochre, Raw Umber, Cadmium Red Pale, Cadmium Orange, Cadmium Yellow Pale, Cobalt Blue, Sap Green, Viridian, and, in the center, White.

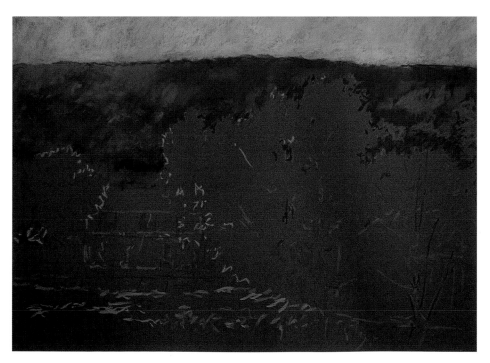

STEP 1. The first consideration before beginning pastel work is selecting appropriate ground color. The landscape depicted is a fall scene on a cloudy day. He therefore chose a warm gray Canson Mi-Teintes paper. Elements in the scene are loosely drawn in with a color complementary to the general color of the subject. Base colors for sky and mountains are loosely applied.

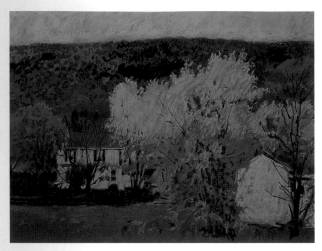

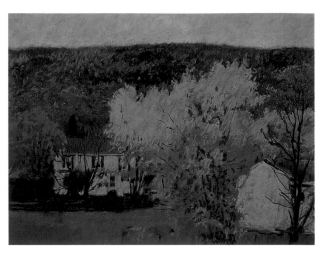

STEP 2. Colors for every element in the scene are quickly painted in. There is no concern for detail at this point. James describes his intent to "simply indicate values" and, at the same time, provide a "strong foundation."

STEP 3. As in his pastel work, James renders background areas first. The artist reasons that working this way enables him "to tell exactly what value and hue to use in order to make the foreground appear correct. Value variations define sky and mountain. His practice of beginning at the top prevents excess pastel color dust from falling onto and clouding colors toward the bottom of image.

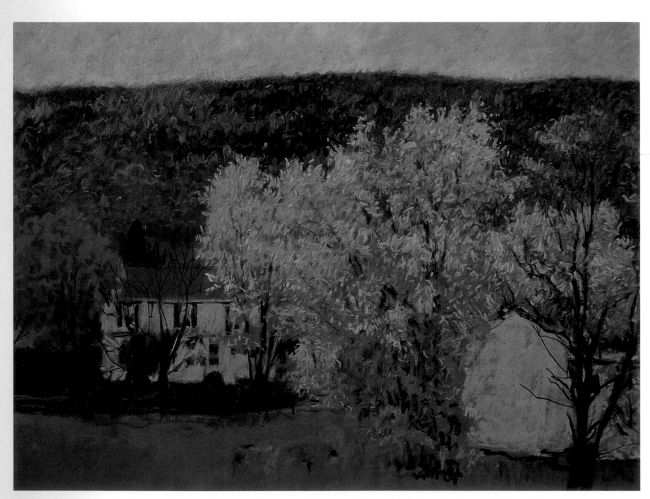

STEP 4. At this point, the large yellow tree becomes the center of interest. Many added tint variations of yellow, pink, and orange increase intensity. The green tree to the upper right of the scene gets similar treatment. James introduces complementary pink color, applied to the mountain area around the tree, to "give it a little more life."

STEP 5. Color treatment in the house and trees located to the left in the landscape verify depth positioning. A lesser use of yellow on the smaller tree emphasizes the larger yellow tree. Different color hues were used to render the white house, reducing its potential distraction from the large yellow tree.

FINISHED PIECE. Bill James. *Fall on Back Road.* 2003. Pastel on paper, 21 × 28 1/2" (53.3 × 72.4 cm)
Collection of the artist

IN THE STUDIO: SEAN DYE

ABOUT THE ARTIST

Award-winning artist Sean Dye teaches at the University of Vermont and conducts workshops throughout North America and abroad. His work has been published in numerous magazines and journals—among them *The Artist's Magazine* and *Pastel Artist International*. He is the author of two books: *Painting with Water-Soluble Oils* and *The Mixed Media Sourcebook*.

Dye is a member of several prestigious pastel societies and is the founding president of the Vermont Pastel Society. His work hangs in many private and corporate collections throughout the United States and Canada, and can be seen at the Sean Dye Studio and Gallery in St. George, Vermont.

COLOR PREMISE

In landscapes, subject matter prompts Sean Dye's color and media exploration. Light and pigment interactions and atmospheric color shifts and movement interest him most. On a toned ground, with color contrast and interaction his goal, Dye often applies underpainting colors opposite to subject color. An underlying structure keeps him from losing focus but provides a jumping-off point for experimentation. The "broken color" effect of his pastels and knife paintings reflects influence from the Impressionists. In a unifying effect, previously applied under-colors show between repeatedly added color dabs.

"It is a challenge to find color in all things," says Dye. Yet he enjoys "searching for color in somewhat colorless subjects such as tree trunks, soil, weathered buildings, rocks, clouds, and washed-out skies." Dye usually adds color interest to shadow areas to "prevent a flat or static appearance." "Invented" colors represent value and intensity in a wider range than found in subjects. To get more "mileage" out of his colors, Dye often applies Josef Albers's belief that "one color can be perceived in many different ways depending on its surrounding environment." "For better or for worse," he claims to avoid no colors.

Dye's work stems from his early geometric abstracts using colors inspired by Italian artists Cimabue, Giotto, Masaccio, and Fra Angelico. Rembrandt van Rijn and Jasper Johns raised his awareness of light and use of color layering. Dye's interest in edges and division of space is inspired by California artist Richard Diebenkorn.

COLOR METHOD

Aside from a colored canvas, panel, or paper, Sean Dye does not think about color at the start. As standard practice, he begins with a value study using charcoal, India ink, or paint on a colored surface. Next, he studies the image to "see if any areas would benefit from 'opposite color' underpainting. Blue sky might be underpainted with red-orange, orange and yellow orange, or green grass with red-violet."

Dye claims to think a lot about color theory and color relationships in making his decisions, which after a while become less conscious. Color schemes factor into his work. Before starting to paint, Dye often pins up color swatches near his easel that serve as reference for color dominance and unity. Some schemes are devised based on complementary, analogous, split- complementary, or triad- or quad-color relationships. (See Chapter Four for a discussion of these schemes.) He warns against complacency: "If you are not thinking actively about color you will create hard-to-break habits and your paintings will begin to look too much alike."

The artist prefers mixing on the palette. "If wet colors mix a bit on the canvas that is OK but color rarely comes onto the painting straight from the tube," he explains. As with most traditional oil painting methods, Dye starts with darker colors. However, like Impressionist painters, he has no problem starting with saturated colors if an image prompts it. In most cases he "waits until late in the painting to apply the lightest and brightest (most intense) colors." His methods vary according to medium.

STUDIO PRACTICE

A virtuoso of multiple media, Sean Dye works with equal confidence in watercolor, soft or oil pastels, traditional and water-soluble oils, gouache, acrylics, and inks, using either a brush or knife. He finds ways to mix compatible media, teaming their characteristics advantageously. Except for watercolor work, Dye never starts with a white surface. He either tones the surface with colored gesso or a solution of the medium to be used. In some cases he chooses a lightfast colored surface such as Pastelbord by Ampersand or Colorfix paper by Art Spectrum, both of which are coated with permanent pigments.

While some artists have eliminated heavy metal pigments from their studios, Dye feels that if "handled responsibly, there is still a place for traditional pigments in the studio." However, when possible he looks to the many excellent synthetic replacements that are now available for such colors. He states, "My water-soluble oil palette is free of potentially harmful pigments."

Dye often paints landscapes in water-soluble oils. When developing early values and "designing" a painting he uses a mixture of Ultramarine Blue and Burnt Sienna. He only mixes a little at a time. By doing this he says, "The color has a chance to drift back and forth between warm and cool passages." For very transparent darks, he mixes Alizarin Crimson and Sap Green. To add deep shadows into green foliage, he uses Sap Green darkened with Blue Violet. To create what he describes as "a wonderful yellow-green suggesting spring leaves," Dye often mixes Marigold and Light Green. One of his favorite traditional oil colors is Violet Gray. To mimic this in water-soluble oils, he uses a mixture of Ultramarine and Titanium with a hint of Blue Violet. According to Dye, "Yellow plus a hint of Blue Violet is a good start for late summer hay as well as for sand. And Titanium plus a speck of Vermilion is great for the lightest part of fluffy clouds."

The development of *Pasture Near Pond Road* illustrates Dye's typical approach. He did a demonstration study for the painting in India ink, acrylic gouache, and oil for his students. First, he sketched with ink on a red-orange canvas and then knifed the rest in oils using a small set of primaries plus Sap Green and Marigold. The painting, begun much like the study, was completed in water-soluble oils. Dye was confident that a warm ground color would provide the desired contrast with cool sky colors and a myriad of greens to come.

ARTIST'S PALETTE

Sean Dye's palette arrangement is based on the color wheel. He puts at least two large squeezes of white in the center. One is for mixing cool colors and the other for mixing warm colors. He switched to almost exclusive use of disposable paper palettes after years of cleaning glass and wooden palettes. He likes the more environmentally friendly practice of discarding hardened paint on paper in the trash rather than pouring wet paint down the drain, which eventually intrudes on natural water sources. He identifies preferred colors in three of his frequently used media. The color lists include his favorite mainstays. However, he occasionally adds other "specialty colors." Notice the slight palette differences between media, all of which are manufactured by Holbein.

Oil-paint colors: Alizarin Crimson, Cadmium Red Light, Cadmium Red Purple, Cadmium Yellow Deep, Cadmium Yellow Lemon, Ultramarine Blue, Manganese Blue, Cerulean Blue Red Shade, Sap Green, Indian Yellow, Burnt Sienna, and Titanium White.

Water-soluble oil colors: Alizarin Crimson, Vermilion, Yellow, Lemon, Ultramarine Blue, Green Blue, Sap Green, Light Green, Marigold, Blue Violet, Burnt Sienna, and Titanium White.

Acrylic polymer emulsion colors: Alps Red, Cadmium Red Light, Cadmium Red Purple, Cadmium Yellow Medium, Cadmium Yellow Light, Marigold, Cadmium Yellow Orange, Ultramarine Blue, Manganese Blue, Hooker's Green, Burnt Sienna, and Titanium White.

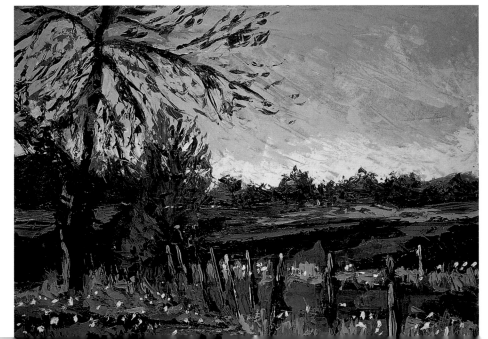

Sean Dye. *Pasture Near Pond Road*, study. 2003. Oil, acrylic gouache, and India ink on canvas, 16 × 20" (40.6 × 50.8 cm)
Collection of the artist

In the final painting, Dye continued to utilize different methods, media, and colors. The artist cites Paul Cézanne as inspiration for the way he incorporates contrasting underpainting color in the finished work. He explains his use of egg tempera for underpainting: "It has vibrant color, dries quickly, and cures to a matte, semi-absorbent surface mechanically bonding with oil paint." Eliminating blue from his usual inclusion of three primaries, Dye underpainted in yellows and reds. His first oil applications introduced naturalistic, yet brighter and contrasting colors—strong reds in foliage and deep blues across the sky. Shadow mixtures continued warm and cool color contrasts. Greens, added later, warmed the sky. In the end, Dye returned to push value and color contrasts, adding greater visual interest and lighting drama to the finished painting than present in its study.

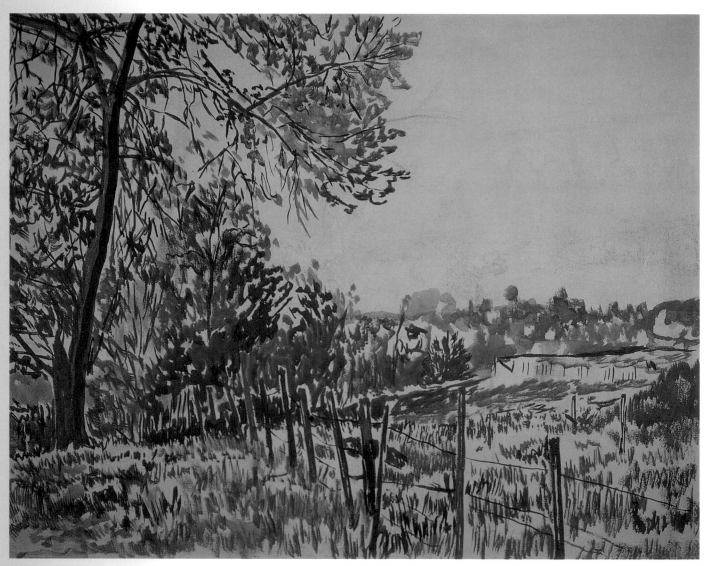

STEP 1. *Canvas prep and sketching.* A canvas of heavy Belgian linen canvas was first sealed with several layers of white gesso. Orange, Yellow Ochre, and Red Ochre in Holbein Duo water-soluble oil paint were combined for ground color. India ink values established his composition plan.

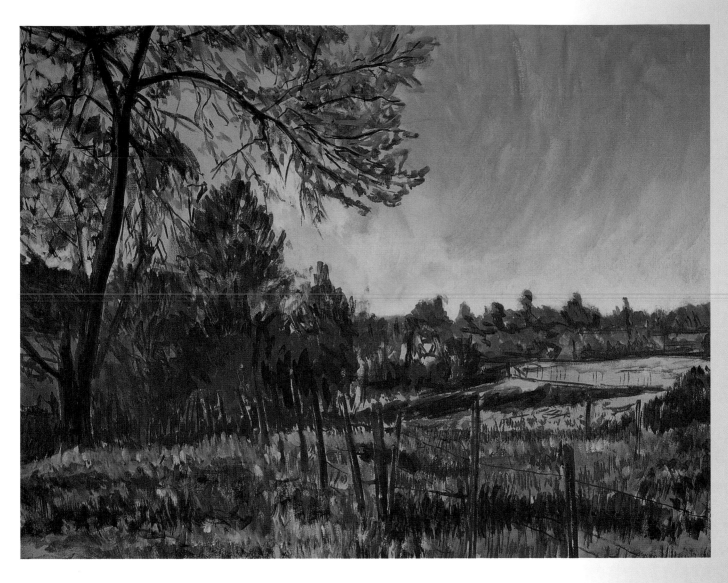

ABOVE: **STEP 2.** *Underpainting.* Egg tempera reds and yellows using warm and cool versions of both: Vermilion and Alizarin Crimson; Yellow and Lemon Yellow. Sky yellows and yellow-oranges were applied with a large flat brush. A #18 round brush was used to apply reds in the vegetation.

LEFT: *Underpainting, detail.* Mixtures vary in warm/cool proportions to suit each area. Dye strives for "colors that would make sense with the final image if they are not fully covered by top layers."

STEP 3. *First oil layer: naturalistic color.* The first sky application, with the palette knife—combining Blue Violet, Ultramarine Blue, Titanium White, and a pinch of Green Blue— is a deeper blue than the expected finished color. (Green Blue's yellowish cast neutralizes Blue Violet.) The underpainting shows through more near tree branches for visual excitement. Patches of Cadmium Barium Red add a strong punch of color throughout the trees and grasses. Dark mixtures for shadow areas contrast greenish "blacks" consisting of Sap Green, Blue Violet, and Alizarin Crimson against purplish "blacks" of Ultramarine Blue, Burnt Sienna, and Blue Violet.

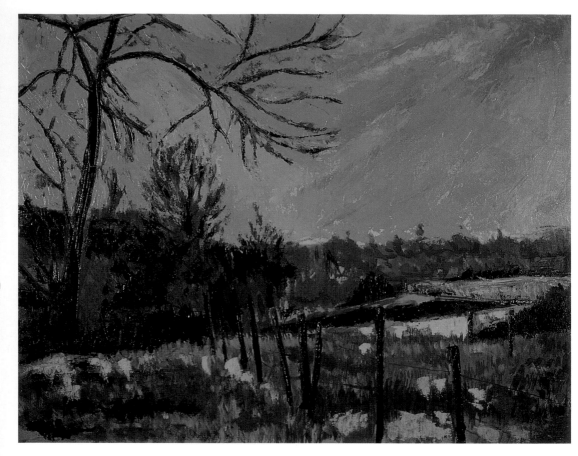

STEP 4. *Second oil layer: greens.* Avoiding what he considers "plastic-looking" greens right out of the tube, Dye mixes a little red with nearly all of his greens. Some start with cooler Ultramarine Blue plus a deep orangish yellow. He mixes Viridian or Green Blue with Lemon Yellow for brighter greens. Many start with a Sap Green base. His darkest greens contain Blue Violet or Alizarin Crimson. Marigold and Vermilion may be added for middle-range greens. Lemon Yellow and white are added for highlighting greens.

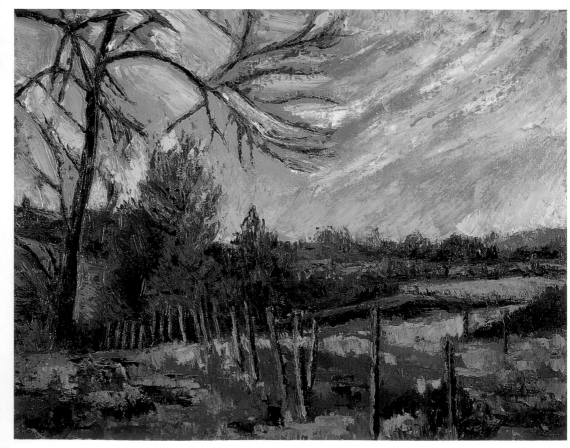

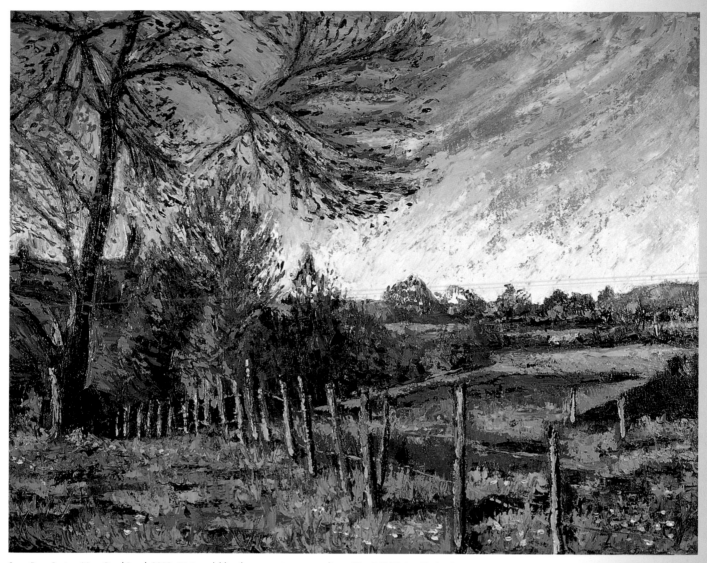

Sean Dye. *Pasture Near Pond Road.* 2003. Water-soluble oil over egg tempera on linen, 28 × 36" (71.1 × 91.4 cm)
Collection of Paul and Lisa Zengilowski

FINAL STEP. *Finishing touches and additional light are added.* To suggest a glow along the horizon, Dye mixed tiny amounts of transparent Marigold with Vermilion and Titanium White. He added this pale orange to the soft blue mixture already used in the sky. A mix of Sap Green and Alizarin Crimson was used to add leaves to foreground tree branches. To dramatize a sense of light from the left, Dye applied touches of pale yellow mixed with either an orange or a green. He also highlighted left sides of branches and fence posts. Yellow, Marigold, and Titanium White mixtures suggest dandelion clusters in the foreground.

COLOR CONCLUSIONS

Sean Dye feels he was very fortunate as an undergraduate painter to have studied with the artist Frank Hewitt. He cites Hewitt's vast knowledge of color theory and history as inspiration for his own research in the same areas. In graduate school Dye says he was lucky to be mentored by color theorist and painter Mary Buckley, with whom he worked for the Josef Albers Foundation. Citing formal education and work experiences in graphic design and architectural color and materials consulting, Dye recalls, "I learned about ideas and color preferences from many others." He has since been teaching about light and color and claims, "I learn something about color from students in nearly every class."

Dye advises developing colorists: "First, go to the library and read as many different theories as can be found. Your newfound knowledge will enable you to piece together the parts of various writings that fit best with your personal color impulses and color thinking. Second, visit museums and galleries often. Seeing artists' works in person is the best way to analyze their color strategies and motives."

Art was the first language. Long before colors had names, much less position on a wheel, people used color to decorate objects and their surroundings, clothing, and even themselves. But we can only speculate about what guided prehistoric artists' color decisions or what they may have known or thought about color.

The word color, originally *colores*, emerged in antiquity during the first century BCE in Seneca. The Greeks and Romans regarded color as having two purposes: decoration and representation. They viewed the former purpose as false (strictly for design embellishment) and the latter as truthful (identified with life or mythology). Color was commonly applied to sculptures and archi-

The first color sphere, which was from seventeenth century, had a ring of four basic colors—red, blue, green, and yellow—and a center grayscale axis ended by white and black.

CHAPTER THREE

CHROMA CHRONICLES

tectural friezes to add visual interest and to delineate one part from another.

Today, on surfaces round and flat and ranging from stone to plastic, and everything in between, color reflects and refutes past innovations and philosophical shifts. Theories about color have spun in circles for centuries. Color studies followed separate tracks for art and science, in part because artists' observations about color generally were not taken seriously by academics. As a result, it is not uncommon for color theory and artistic practices to contradict one another.

Nonetheless, scientific enlightenments on color have significantly influenced artistic thinking. Today, color knows many purposes, from mere decoration to veritable subject. Each generation of artists assimilates the growing bank of color knowledge. And each new generation looks to break so-called rules, to challenge the accepted, and ultimately find their own way.

COLOR ACCORDING TO ACADEMICS

SCIENTISTS WERE FIRST to codify color. In order to measure and neatly define it, color must be examined out of context, separated from real visual experience. All manner of geometric form and order have been employed toward the inevitably futile goal of all-inclusive, ordered color analysis. Artists comprehend and utilize color in ways too personal and abstract to be measured.

Yet, science influences art methods and art instruction. The earliest formal color training, in eighteenth-century European art academies, avoided color mixing. As deliberation persisted among instructors, students attended to copying masterworks. Current color teachings link artists with past philosophers, mathematicians, scientists, psychologists, and inventors.

LOOKING FOR LOGIC

The best minds of antiquity proposed various color treatises. Color was considered a mystery from the gods—as something that pigments were incapable of re-creating and humans unable to judge. Plato suggested the eye as the source of light, with white emanating from it. During the Middle Ages, all matter was thought to contain light. For centuries, color theory was little more than a system of symbolism and identification. Even as color gained importance—to keep in step with growing demands of private patrons and for religious commissions—methods and theory remained rudimentary. In perhaps the earliest historical reference to optics, about 1000 CE, Arabian physicist Alhazen proposed that light travels into the eye. Understanding visual color perception was still centuries away. Eventually advancements in chemistry and physics contributed to thinking of color in technological rather than just metaphysical terms. While early studies often contradicted one another, they introduced a new color language and had a far-reaching influence.

Through working with dyes, textile makers learned ahead of artists how to mix colors. The concept of primary colors, delayed by artists' reluctance to mix, emerged about 1600 in discussions among chemists. Blue, despite its religious symbolic status, was originally overlooked as a basic color. Titian's preference for blue stimulated new interest in it. Archaic words citing black could also translate to blue, thus converting the ancient Greek four-color palette of white, black, yellow, and red. Eventually, white was separated, leaving three primary colors: blue, yellow, and red.

COLOR FORM Astronomer **Aaron Sigfrid Forsius**'s (d. 1637) color system went undiscovered for more than three hundred years. If drawn flat, his diagram is remarkably similar to present-day three-dimensional color models. (See illustration on opposite page.)

COLOR LINEUP A Jesuit mathematician, **Athanasius Kircher** (1602–1680) considered colors to be the product of light and shadow, as did Aristotle. His 1646 book *The Great Art of Light and Shadow* noted inherent value differences among hues. It was the last such reference for hundreds of years.

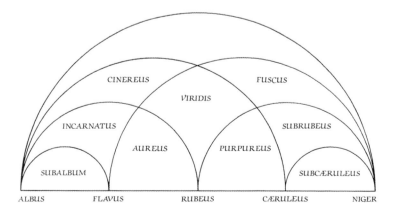

Kircher's color lineup with mixing arcs: albus = white; flavus = yellow; rubeus = red; caeruleus = blue; niger = back; aureus = orange; viridis = green; purpureus = purple

a neutral-toned canvas. High-fashion black was commonly worn for portraits and artists learned to represent black using color variations. Vincent van Gogh once claimed to have counted twenty-seven different blacks in a Frans Hals (1581/5–1666) portrait. With a palette more colorful than most of his contemporaries, Peter Paul Rubens (1577–1640) liked to contrast colors, warm against cool, dark against light. Jan Vermeer's (1632–1675) blue and yellow emphasis reflects an accepted view that they were the primaries of light. No longer just for holding color, palettes became mixing surfaces.

ROCOCO (c. 1700–70) Though it has affinities with the preceding Baroque period, Rococo has many distinctive qualities—among them, an expression in a wide range of luxurious decorative arts and a penchant for whimsical and lighthearted subjects imbued with a wistful and nostalgic tone. Though not exclusive to the period, the Rococo palette tended to be delicate and subtle. A scholarly color debate arose between rival English portrait painters when Sir Joshua Reynolds (1723–1792) declared blue, a cool color, suitable only for backgrounds and inappropriate for a main subject. Thomas Gainsborough (1727–1788) countered with his *Blue Boy*, a portrait of a boy dressed in bright blue against dull warm colors, proving that adjusting intensity can compensate for temperature difference. Specifically, a bright, albeit cool blue, can visually project more than a warm color sufficiently browned-down.

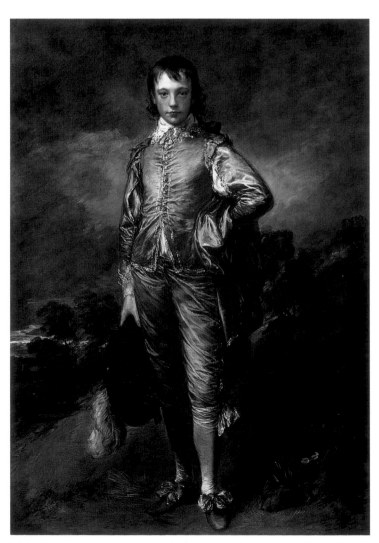

ROCOCO. Thomas Gainsborough. *The Blue Boy.* 1770. Oil on canvas, 70-5/8 × 48-3/4" (179.4 × 123.8 cm). Reproduced by courtesy of the Huntington Library, Art Collections, and Botanical Gardens, San Marino, California

NEOCLASSICISM. Jean-Auguste-Dominique Ingres. *Napoleon I on the Imperial Throne.* 1806. Oil on canvas, 8'6" × 5'4" (2.59 × 1.62 m). Musée de l'Armée, Paris

ROMANTICISM.
Eugène Delacroix.
*Liberty Leading the People,
28 July 1830.* Oil on
canvas, 8'6³/₈" × 10'8"
(2.60 × 3.25 m).
Musée du Louvre, Paris

NEOCLASSICISM (c. 1770–1850) The French art Academy prescribed Classical and Renaissance themes, dark color, and formal studio sets. Through glazing and delicately brushed blending, portrait painters Jacques-Louis David (1748–1825) and Jean-Auguste-Dominique Ingres (1780–1867) set standards of perfection in detailed rendering.

ROMANTICISM (c. 1800–50) Artists exaggerated color to articulate literary, religious, and social-comment themes. Red and white gave emotional charge to Francisco de Goya's (1746–1828) civil protest of unwarranted execution in *The Third of May, 1808*. A devoted student of color, Eugène Delacroix (1798–1863) applied Chevreul's theories, progressing to pure, often complementary color juxtapositions, for a heightened sense of light and expression. Delacroix dismissed Neoclassical manipulated detail, particularly in paintings by Ingres, as "gaudy and cold." Red adds passion to his *Liberty Leading the People*.

REALISM (c. 1820–1900) Artists sought to duplicate local color. English landscape painter John Constable (1776–1837) wanted to capture warm sunlight and cool shadows as the eye really sees them. He depicted *specular reflection* (direct sunlight) glare on tree leaves using patches of white paint that people called "Constable's snow." Landscape painters sought to naturalistically represent ordinary subjects and quiet scenes. Thomas Eakins's (1844–1916) sculling scenes avoided narrative suggestion in favor of honestly recording direct observations.

IMPRESSIONISM (c. 1860–1900) Rebellious young artists contradicted Neoclassical dogma and Romantic themes by redefining realism in brightly colored portrayals of natural light and everyday, often urban, scenes. Camille Pissarro (1830–1903), Alfred Sisley (1839–1899), Claude Monet (1840–1926), Pierre-Auguste Renoir (1841–1919), and others avidly studied Chevreul. Refusing tedious academic detail,

COLOR MOTIVATIONS

ANALYSTS SUGGEST three main categories of art-making motivation: imitational, formal, and emotional. Determining motivation provides clues to appreciating artists' color use. Although art-making premises and stylistic tendencies often coexist, one of the three motivating factors will tend to dominate in the work of an artist.

IMITATIONAL "What is it?" People who expect artworks to mirror reality might ask this question when confronted by an abstract painting. Ever since Plato and Aristotle proposed imitation of nature as the aim of art, color has long been important to pictorial representation. Those who prize realism above all have less interest in a work's message or method and may object to deviation from local color. A large percentage of artworks lie somewhere between absolute realism and abstraction and contain subjects that are identifiable even when stylized or distorted.

In the scope of representational works, artists and critics often disagree on what constitutes realism. As a worthy artistic goal, realism is ironically founded on the ancient Greeks' perfectly proportioned idyllic representations of gods, rather than imperfect real people. Such philo-

Thomas Nash. *Roby Robinson.* 1999. Oil on canvas, 44 × 32" (111.8 × 81.3 cm)
Collection of Sun Trust Robinson Humphrey, Atlanta, Georgia

Color is essential to portraiture's imitational premise. The ability to realistically portray subject and setting appropriate to commission demands is key to success for portrait painters. In his portrait of Roby Robinson, CEO of Robinson Humphrey in Atlanta, Thomas Nash had to know how to work colors to depict many subjects, including skin. His color manipulations ("doctoring" colors for visual impact) may in no way suggest anything other than reality.

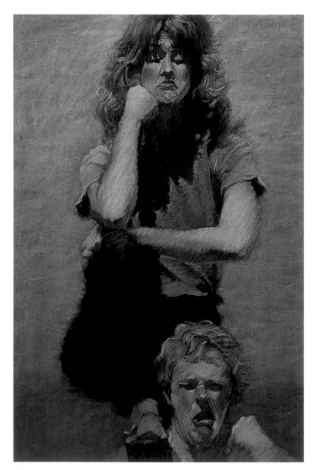

Bill James. *Mimes at Wolf Trap.* 2000. Pastel, 31 × 22" (78.7 × 55.9 cm)
Collection of the artist

Since *Mimes at Wolf Trap* is not a portrait, subject identity is inconsequential. Viewers looking for realism might praise its proportions, believable lighting, and color. Yet, Bill James, motivated by emotional attraction to the facial expressions, did not adhere strictly to what he saw. He recalls formal consideration of the color scheme, "I changed the color of their shirts and created the background using green and complementary yellow to add interest."

sophical dichotomies reappear throughout art history. The mid-nineteenth-century invention of photography prompted less realistic approaches to subjects. Some artists began to see exclusive concern for realistic rendering as superficial.

Just as definitions of "realism" have evolved, so have color practices employed to achieve it. Artists have proposed diverse color recipes for representing flesh, some excluding, others requiring the use of blue. Color in pursuit of realism continues to change as artists consider new ways to see and think about color.

FORMAL "How was it made?" This question reveals preference for strategy over subject. Composition, media, and technique are criteria for judging artistic appeal. Formalists solve design problems, structure methods, focus on elements, and tend to view color abstractly, regardless of subject.

Though overshadowed by a long historical preference for representation, formalism has always been evident in art. Ancient examples include the Egyptians' prescribed frontal style and the Greeks' mathematical formulas for proportional "perfection." Compositional obsession rose to new heights during the Renaissance when linear perspective was devised. In the mid-nineteenth century interest in theory and process pushed color issues forward.

Titles can divulge artists' premise. For example, Matisse's *Green Stripe (Madame Matisse)* emphasizes color and value over subject identity.

Artists recognize that viewers may impose an aesthetic framework different from their own. Abby Lammers's departure from naturalistic color, in otherwise realistic images, flags her work as something other than strictly imitational. Yet, an imitational-biased eye would find merit in Lammers's accuracy of form, despite her evident toying with color schemes. Color variations of the same composition confirm Lammers's formalism.

Abby Lammers. *On a Roll*. 2003. Acrylic on paper, 36 1/2 × 27 1/2" (92.7 × 69.9 cm) *Private collection*

In *On a Roll* Abby Lammers zoned dark, middle, and light values from background to foreground.

Abby Lammers. *Mixing with the Wrong Crowd*. 2003. Watercolor and acrylic on 140-pound Arches Aquarelle cold-press paper, 30 × 22" (76.2 × 55.9 cm) *Private collection*

Reversing color in *Mixing with the Wrong Crowd*, Lammers was "looking to achieve an illusion of transparent cellophane using a full palette."

COLOR CONCLUSIONS

Jeanne Carbonetti notes, "The art world changed forever when people like Cézanne, Monet, Van Gogh, Matisse, and Picasso each said, 'I can't paint *their* way anymore. I will paint *my* way'." As a student of art history, she finds it a "delightful paradox" that education and experience have taught her the same lesson, "It is only when you are truly yourself that you can relate to others effectively in art." She advises artists to study when not painting, to think about art, and reflect upon it. And then, when in the studio, "Play, experiment, and risk a whole painting just to see what happens. Somewhere between the thinking and the playing, the true artist shows her face."

STEP 4. *Building up of earth forms.* A single color of brilliant orange is applied on patches of wet paper. This allows for some edges, which indicate plane changes. More pigment is added in places to allow full-color saturation to add weight and focus to the flowers. The color is allowed to run over the black, creating a more subdued mix of hue and value.

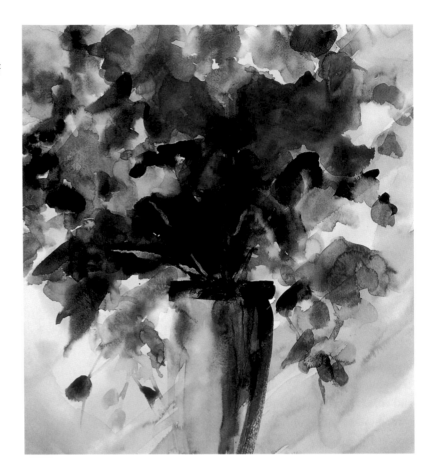

STEP 5. *Reality begins.* At the end of the build-up stage, more edges are still needed. Some centers of bright violet are added and a blue, then green, leaf form is added here and there, letting more dry edges create texture. Later strokes are more calligraphic and their edges are much less blended.

Jeanne Carbonetti. *Eastern Light.* 2003. Watercolor on paper, 22 × 25" (55.9 × 63.5 cm)
Collection of the artist

FINAL STEP. *The greater sun.* In the last moments of the painting, the sun source is glazed diagonally across the painting from top right to bottom left, with an emphasis on the right. This highlights the focus and gives much greater weight to the forward space versus the background space, without the need for spatial landmarks of any kind. Creation is complete.

IN THE STUDIO: THOMAS NASH

ABOUT THE ARTIST

Thomas Nash has been a full-time professional portrait painter since 1971 and has taught and attended numerous workshops over the years. An award-winning portrait painter, Nash's studio was featured in the February 1992 issue of *American Artist* magazine. He has served on the advisory board of the American Society of Portrait Artists, is the former president of the Portrait Society of Atlanta, and has lectured at conferences of the Portrait Society of America. Notable among his recent commissions are the official portraits of former Georgia Governor Zell Miller and former Speaker of the House Newt Gingrich. The former mayor of Atlanta, Ivan Allen Jr., also posed in Nash's studio for his portrait. Nash lives with his wife, Donna, in Roswell, Georgia.

COLOR PREMISE

As a professional portrait painter in oils, Thomas Nash finds he must balance method and color logic with representational concerns. When painting a portrait, "it's important to remember what your priorities are," he says. For example, capturing the light effect of a season or time of day is but one possible goal when making a painting. "In my field," warns the artist, "if I succeed in capturing a sunny morning in spring yet miss the child, I have failed." The same principle applies to the idea of trying to find as many color variations as possible. "For the colorist," Nash continues, "it may be satisfying to record two hundred unique mixtures of color in the reflection on the side of a brass pot. But even if you can do the same thing with an ear or a nose, it may not necessarily advance the characterization of the individual."

Nash stresses that to paint realistically, the best way to approach color is to combine observation with knowledge and thinking: "In a pure observational approach one doesn't even have to know what one is looking at. You scan your subject as if it were a flat mosaic and ask yourself a thousand questions about how every spot of color compares to every other spot. In a purely analytical approach you would learn about the nature of light on form, then 'figure out' how to make something appear real. You also need to know how distance and atmosphere affect the way we see color. With this knowledge one can ask, 'What is the light *doing* in the scene before me?'"

The artist enjoys the mutual reinforcement of combining what he knows with what he sees. "We can never return to the so-called 'innocent eye' of a baby. We have learned to not see just spots of color when we look at the world and we don't want our viewers to just see spots of color in our paintings either." Nash warns, "A painting done from a purely 'match the spots' approach may glisten with light and charm but lack a feeling of solidity and form. On the other hand, a painting done from a purely analytical approach may lack the magic and glow of life that comes from direct observation." Nash aims to understand and use both approaches, striving to impart what he feels and not just what he sees.

He advises that knowing about the nature of light and color allows painters to better control their work: "No one wants to be slave to the scene observed. Yet if we arbitrarily alter things without a good understanding of why things appear the way they do, we can have unpleasant surprises. If we add a touch more red in the nostril will it look like it 'glows' from light coming through the flesh or will it simply look like a bloody nose? Do we try too hard to emphasize the highlights and wind up making skin appear as chrome or a wool suit as plastic? Also, because it is not always possible to set up the scene exactly as we wish to paint it, the artist must know how to alter things and still make them convincing. This can only come from knowledge and understanding, not just highly refined copying skills."

COLOR METHOD

Influenced by the Munsell Color Notation System, Thomas Nash constantly thinks in terms of the three color characteristics: hue, value, and chroma, or brightness. He will use a color straight from the tube if that color is exactly what he sees, but finds that some modification is usually needed. Nash tries to identify hue, value, and chroma of any spot of color before mixing it. He notes, "Usually one of the three is more apparent than the others and can help in deducing the less obvious ones." Here Nash relies on his understanding of Munsell's color notation specs. As an example, he explains, "A high-chroma yellow cannot be very dark in value, but on the other hand, the value of a very high-chroma red or blue must be somewhere in the middle range." Nash points to the importance of getting

one of the three characteristics right as soon as possible. "My pecking order is hue, value, and then chroma," he states. "When value dominates over hue, it is too easy to 'settle' once the image starts to take form on the canvas rather than to push to discover more and to paint with greater color sensitivity."

In considering options for producing a color Nash chooses parent colors likely to provide additional needed mixtures. For example, he often combines "near complements such as Cadmium Red and Cadmium Green mixtures and variations." The same red used to "warm a subject's cheeks" might also be mixed with green for "a more neutral area of the face."

Nash taps various methods for altering color character while painting. He notes, "All oil paint is somewhat transparent and will eventually show something of the color beneath. It is easier to 'kill' a color than to intensify it." To dull a color he may use either a complement or a duller version of that same color. "I try to understand what is happening color-wise on my subject and devise ways to mix those colors in an orderly and controlled way so that it is easier to make fine adjustments," he says.

He works some areas of his paintings in layers, allowing each to dry before adding more paint. Compared to an opaque approach, glazing requires a different strategy. Regarding glazing, he claims, "Light bouncing off a lower layer and coming back through a top layer of paint creates an effect that cannot be matched any other way." He further explains, "More often I layer paint simply to keep it flat. A physical buildup of ridges from thick brushstrokes can catch the light and create a glare that detracts from the image, especially in darks such as in navy blue or black suits."

Nash suggests disregarding all else when studying color, delving into its isolated parts. "Observing and identifying color relationships is not the same as paint mixing skill. Paint

NASH'S COLOR CHARTS. For many years Nash separately charted colors for quick visual reference. Various charts explored and recorded mixtures, compared colors between brands, noted color characteristics, and so on. Frustrated by the difficulty of comparing colors on separate charts, Nash now individually records each color on a "tab" (six-inch strip of linen canvas mounted on matboard), allowing for greater comparison potential.

TAB COMPARISON. Winsor & Newton Transparent Yellow and Mussini Cadmium Yellow Light. Nash puts identification notes on one side of each tab and paints the surface of the other side. A black line was applied to the canvas first, in order to reveal paint transparency. After a generous paint application, he sometimes wipes off a portion to display what a "stain" of the color would look like. A comparison of these two tabs shows greater transparency in the Winsor & Newton sample.

TAB DISPLAY. This is a fraction of Nash's extensive tackle-box-organized tab project. Some boxes contain spectral colors, some all grays, others neutral, and other special mixtures. Fifty of the trays correspond to the Munsell system, labeled according to Munsell's ten-step wheel. So far Nash has made one box each for five steps of chroma from dullest to most intense. More can be added. Each box contains up to ten value samples.

mixing is about materials, about what your paints can and cannot do." He claims, "learning to recognize color relationships is the hardest part." Nash suggests making charts or "tabs," as he calls his swatch references, as a swift and effective learning approach: "I have always been fascinated by simultaneous contrast. With these tabs I can assemble a group of colors and see 'what they do to each other'. I also know exactly how I mixed them. I can test my basic color judgment and get an answer right away. If I surmise some object's local color to be a value 5 Raw Umber, I can reach for a tab

and check to see if I am right or not. It sharpens my color judgment and helps me to relate what I see to the actual materials I use when painting."

Nash tries to determine the Munsell notation for each tab. "Some manufacturers like Holbein provide this information. Liquitex used to do it and I still have many of their paints," says Nash. He can then cross-reference with makes that do not specify.

STUDIO PRACTICE

Before beginning work on a final canvas, Thomas Nash does compositional studies, which also serve as color studies. Trials on the smaller canvas precede significant changes to the final work throughout much of the project, which help to "save time and avoid a lot of overpainting and scraping corrections."

He mixes color, either on his palette or directly on canvas. For studies, he mixes more often on the canvas. "I concentrate on a few key spots and make 'puddles' of color that I adjust on the canvas. Using what I learned in the study I can then get the color closer to what I expect to end up with," he explains.

Nash focuses on likeness first in a value study and then in color. His initial sitting with each subject helps him to decide what lighting to use. "Because of the head's special significance in portraiture, I first determine how it needs to be positioned and lit before going any further with the pose," he explains. Painting a color study of the head provides another opportunity to confirm that he has selected a "telling" and characteristic approach. Nash views each portrait as "an adventure." Composition, seen by him as an integral part of "solving the problem," is given a great deal of consideration.

The extensive depth of color research and life study preparation that goes into each of Nash's portraits pays off in finished quality. His portrait of Dr. Raymond Morrissy illustrates the various stages of the commission's development.

ARTIST'S PALETTE

Thomas Nash uses two palettes. The first has many colors, with clove oil added to each of the piles to retain wetness. These paints are ready to use quickly when he wants to create a color study. If clove oil is avoided in his paint (when starting a commission), Nash puts out fresh paint on a different palette, which usually contains fewer colors. He generally arranges colors in a sequence as if on a color wheel. The less chromatic earth colors are placed in a second row just below their corresponding purer color. He uses a combination of mostly Winsor & Newton, Holbein, Old Holland, and Rembrandt oil colors.

When Nash finds himself returning to a particular combination of colors again and again he mixes and tubes these colors for convenience. In particular, he has three favorites of his own:

- "Tom's Violet," a mixture of one part Dioxazine Violet and two parts Ultramarine Blue, which he describes as "a clean, dark, intense blue violet"
- "Tom's Yellow Green," a mixture of equal parts Cadmium Green and Cadmium Green Pale
- "RuBu," a mixture of equal parts Raw Umber and Burnt Umber

Nash's full-color palette contains: Lemon Yellow, Cadmium Yellow Pale, Cadmium Yellow Medium, Cadmium Orange, Cadmium Scarlet, Cadmium Red, Cadmium Red Deep, Permanent Rose, Alizarin Crimson, Permanent Magenta, Dioxozine Violet, "Tom's Violet," Ultramarine Blue, Phthalo Blue, Cerulean Blue, Manganese Blue, Phthalo Green, Viridian Green, Cadmium Green, "Tom's Yellow Green," Cadmium Green Pale, Raw Umber, "RuBu," Burnt Umber, Transparent Red Oxide, Yellow Ochre, Ivory Black, Titanium White, and Flake White.

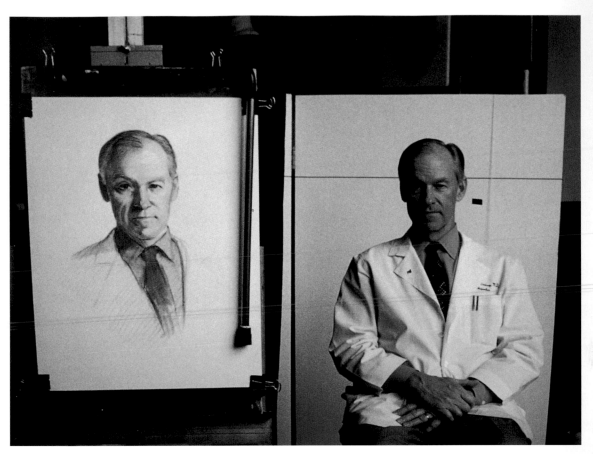

STEP 1. *Head study.* Nash begins each portrait with a charcoal head study from life. The pose for the final portrait is undetermined at this point.

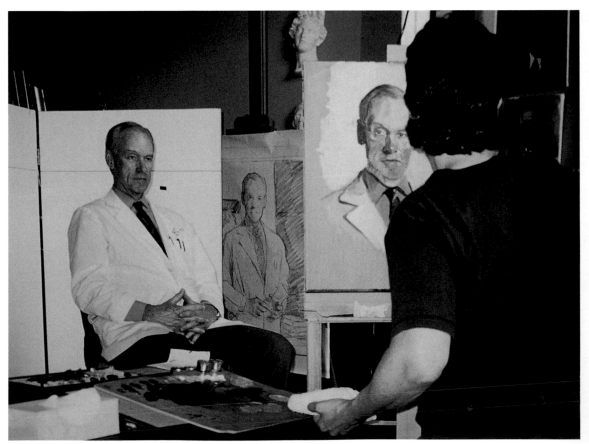

STEP 2. *Color study.* Although Nash determined that the doctor would be standing in his portrait (note a full-scale cartoon of the painting against the back wall), he was seated during a color study of his head and shoulders.

STEP 3. *Life painting on canvas.* Although he also employs reference photographs, Nash finds it easier to capture true colors from life. A clothed manikin, books authored by the subject, a table, and related props fill in whenever the subject is absent.

COLOR CONCLUSIONS

Thomas Nash feels that an artist can greatly benefit from taking the time to learn about the nature of light and color as well as the possibilities and limitations of materials. He advises that to study anything, one should first isolate the problem. To explore color he recommends a very simple outdoor, sunlit still life as a great place to start. "Portraiture is probably the worst subject matter to paint when first learning about color and materials because a desire for capturing the sitter's likeness will distract from other goals."

Regarding color mixing, Nash warns artists to be wary of a few pitfalls related to certain color types:

- Very pure colors: "Keep at least one of the three primary colors out of the mixture."
- Very dark colors: "Once you introduce white, yellow, or other high-value paint, it is difficult to ever achieve a very dark 'inky' mixture."
- Very light colors: "Start with white and slowly add modifiers."
- Very transparent colors: "If you want a true glazing color, keep the opaque paints out."

Detail of finished piece, hands. Nash pays nearly as much attention to hands as he does to a sitter's face. The protractor he is holding provided an interesting and appropriate prop for an orthopedic surgeon.

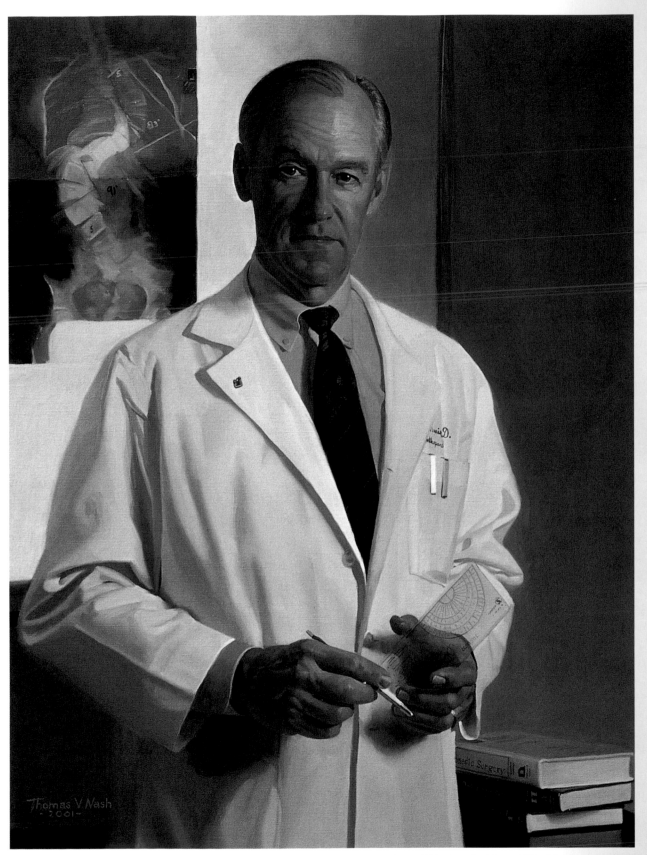

FINISHED PIECE. Thomas Nash. *Raymond T. Morrissy M.D., Medical Director, 1983–97, Scottish Rite Children's Medical Center.* 2001. Oil on linen canvas, 36 × 28" (91.4 × 71.1 cm)
Collection of Children's Healthcare, Atlanta, Georgia

The color wheel is basic, yet bunk. It appears to tell the whole story of color in an evenly segmented nutshell, but much is overlooked. Nevertheless, the color wheel remains fundamental to color instruction. Taken literally, however, it becomes a source of confusion and frustration.

While a color wheel offers a general guide for paint mixing, actual results may deviate unexpectedly because pigments do not perfectly match theory colors. Real colors each possess unique characteristics far too multifaceted to chart accurately on a flat wheel. The terms defined below were developed by color theorists to differentiate color qualities. They will come up throughout this chapter as we look at how color wheels help us and hinder us.

A color wheel made using Color-aid silkscreen printed papers, formulated to represent the basic twelve colors

CHAPTER FOUR

COLOR WHEEL CONFESSIONS

HUE Another word for color, *hue* refers to a basic color category—such as red, blue, or yellow—that is determined by light wavelength range.

VALUE Intrinsically, *value* refers to gradations of lightness or darkness. A color's value is determined by its comparison with a black-to-white grayscale. If discussing the amount of light energy reflected, it also refers to brightness.

CHROMA The degree of color saturation, as compared to neutral gray, indicates *chroma* (a term used more in scientific color discussion). It also describes a color's *intensity* (a term more familiar to artists and color theorists) in terms of brilliance or dullness. In media, color saturation directly relates to the percentage and purity of pigment content.

TEMPERATURE A color's perceived sense of warmth or coolness.

COMMON COLOR SCHEMES

WHEELS and their geometric cousins present color in symmetrical balance, implying a basis for harmony in design. Color is key to harmony in visual art, a concept rooted in ancient Classical Greek ideals of beauty and balance in all things.

Color schemes are formulaic. Their exact arrangements, as with the color wheel, exist only in theory. Real colors vary too much to behave according to formula.

The color schemes discussed and illustrated over the next several pages in this book are the standard fare of many art instruction programs. These schemes speak to a universal visual need for color balance. They should be considered as concepts rather than rules.

COMPLEMENTARY OPPOSITION

Complementary colors are direct color wheel opposites. The basic pairs—red/green, yellow/violet, and blue/orange—each consist of a primary color and a secondary color, which is a mixture of the other two primary colors. "Complementary" is an appropriate term because opposite colors complete each other. They share no common color and offer the greatest possible color opposition with the most powerful visual impact.

Color wheels give a reasonable idea of opposite pairings. Literal complementary matches in artists' paints do not exist, due to pigment color bias. Generating a visual afterimage is a precise method for determining any color's true complement. If a color is stared at intently for about thirty seconds, looking quickly to an achromatic surface produces an opposite color afterimage. The effect fades within seconds but lasts longer for brighter colors. Complements work either together or against each other; they become brighter if juxtaposed or dulled when mixed.

TETRAD PAIRINGS Four colors at corners of either a rectangle or square superimposed on the wheel make for strong oppositional

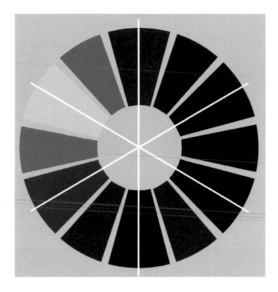

COMPLEMENTARY COLOR PAIRS. Primary colors and their secondary opposites are the most familiar pairs of complements. Infinite polar matchups are possible when spinning a bisecting line around the wheel. Interestingly, each set of tertiary opposites contains two sets of complements. Example: Yellow-green is opposite red-violet, which contains complementary pairs red/green and yellow/violet.

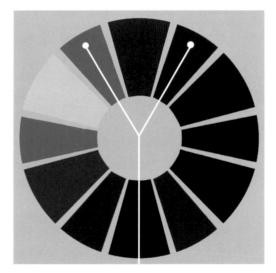

SPLIT-COMPLEMENTARY. A color opposed by the two tertiary colors on either side of its direct complement, offering strong visual impact similar to, yet not as strong as, the contrast between direct opposites. Example: Blue/red-orange/yellow-orange.

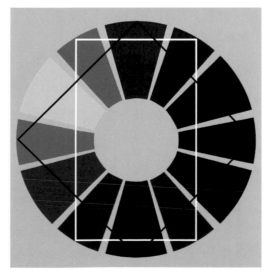

TETRAD. The white rectangle joins colors on either side of complements blue and orange (red-orange/yellow-orange/blue-green/blue-violet). The result is a rectangle of nearly complementary parallel matches. The square formation pairs perpendicular sets of complementary colors. Black lines connect blue/orange with red-violet/yellow-green.

ACHROMA

THEORIES ABOUT the relationship of black and white to color differ. Assertions that both are devoid of color are common. Theorists of antiquity aligned colors between black and white, suggesting that all originate from mixtures of the two. Ignored by color wheels, black and white darken or lighten color value.

LIGHT VERSUS PIGMENT

Definitions of black and white seem contradictory. One defines white as the absence of color and black as the combination of all colors. Another states the reverse. Appropriately applied, both interpretations are accurate. The first refers to light and the other to pigment.

With regard to light, white embodies all colors; black contains none. Light from the sun is the source of all color that we see. White indicates the reflection of the entire visible color spectrum. Black indicates the absence of color (the absence of light). When the eye sees white, it really sees all visible light wavelengths at once, which the brain interprets as white. When the eye sees black, it sees no reflection of light because all wavelengths are absorbed.

With pigment, the definitions are reversed. White contains no color. All colors emanate from mixtures of the three primary pigment colors: red, blue, and yellow. It follows that black may be created from a balanced mixture

Caroline Jasper. *Light White Cotton.* 1994. Oil on canvas, 32 × 25"
(81.3 × 63.5 cm)
Private collection

I used many colors when painting the white shirt in *Light White Cotton*, adding interest and drama.

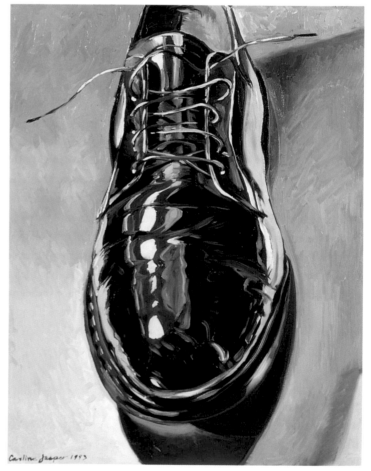

Caroline Jasper. *Weekend Warrior.* 1993. Oil on canvas, 32 × 25" (81.3 × 63.5 cm)
Collection of Dan Whipps Photography

To render the black shoe in *Weekend Warrior*, I used many colors but no black.

of primary colors. Yet, paints could be mixed all day and fail to make black. A dark neutral gray, at best, may be expected. Black paints, however, may be purchased. Pigment resources provide for very dark neutral colors such as Mars Black and Ivory Black. Artists who avoid using manufactured blacks prefer mixing their darkest paints to create substitutes for black that, by their mixtures, relate to other palette colors.

COLOR IN BLACK AND WHITE

Whites and blacks in artists' pigments and surfaces vary in their content, causing light to be absorbed and reflected differently. Furthermore, pigments are no match for light energy; their value range is far less than what the eye perceives in nature.

Surfaces cannot reflect the full strength of light that strikes them and cannot deliver brilliance equal to the sun's retina-risking full *spectral reflection*. If white paint could equal the sun's glare, viewers would need to squint when looking at paintings. Even the purest and brightest white paints absorb more than half of the light received. Artists must resort to trickery to represent on painted surfaces, which are only able to reflect light, the intensity of light and color visually experienced in direct sunlight.

When we do not use color to paint things we think of as colorless, the result looks artificial. Black and white objects do not exist in a colorless environment. On any surface, in any pigment, when even the slightest degree of light exists, so does color. Objects hint of color from light sources or neighboring surface reflections. Observant artists often incorporate many different colors in representing either black or white. The presence of a full complement of multiple, unmixed colors can stand for neutral color. White surfaces, even non-glossy ones, are quite reflective. Any color is darker than white and can therefore be read as shadow. Any color is lighter than black and therefore can represent mid-tones darker than white.

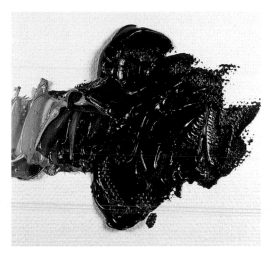

"BLACK" MIXTURE (WITHOUT BLACK PAINT). The darkest colors on my palette are typically Ultramarine Blue and Crimson Lake. Mixed together, they make a violet that appears nearly black. Adding a little touch of yellow can negate evidence of violet. In this case Permanent Yellow was used, but any type of yellow will have a similar neutralizing effect. (Holbein Artists' Oil Colors)

BLACK POWER

Color-value charts generally center a pure color between darker and lighter blocks on either side, implying equal amounts of black or white additions to alter its value. Experience teaches otherwise. More white is required to lighten, very little black to darken. Inherently, color-value differences preclude positioning between equal dark/light intervals.

Black paints have a long history in art. Opinions differ strongly on their use. Some artists hold black essential while others never use it. A handful of artists, however, are known for their masterful use of black, Velázquez, Édouard Manet, and Whistler among them. Renoir claimed, "I've been forty years discovering that the queen of all colors is black!" Some disciples of black paint use it exclusively to mix color shades and rely on it to deepen shadows for greater contrast.

Delacroix noted that colors "dirtied" if mixed with black. Tempted to apply black for shadow strength, artists often find the effect too strong. In figure paintings where black is a darkening agent, subjects are liable to look more dead than alive. Black, by itself, can look foreign and unrelated to polychrome images. Pure black marks among colors have been described as "black holes" in a canvas. Those who shy away from using black paint rely on their darkest colors as alternatives for "black" representations.

PALETTE PRIORITIES

OLD MASTER PALETTE. Robert Gamblin of the Gamblin Artists Colors Co. has identified colors that emulate old master favorites. Center: Flake White replacement replicates the working properties of original Flake White without the lead content; clockwise from bottom: Ivory Black, Venetian Red, Burnt Sienna, Transparent Earth Yellow, Transparent Earth Orange, Transparent Earth Red, Asphaltum (makes a lightfast match to a popular nineteenth-century glazing color), Terre Verte, Yellow Ochre, Cerulean Blue, Ultramarine Blue, and Cobalt Green. Naples Yellow Hue is not shown.

MINERAL PALETTE. Robert Gamblin's choices for an Impressionist's palette feature mineral color innovations that quickly gained popularity upon their mid-nineteenth-century arrival. Clockwise from bottom: Cadmium Yellow Light, Cadmium Yellow Medium, Cadmium Red Light, Alizarin Permanent, Ultramarine Blue, Cerulean Blue, Viridian, Ivory Black, and Flake White replacement.

WHEN IT COMES TO selecting colors from the vast options available, those looking to save money go for packaged sets of paints containing color wheel names. Those who are focused on color theory and looking for artist-grade media try to match tube colors with wheel colors. The ones who wonder if enough colors are available to represent all that is seen in real life are liable to buy a sample of nearly everything on the market. Others argue that only a few good colors are needed to depict anything and everything.

Some artists hold to traditional spectral palette arrangements. Others work intuitively as did Matisse, who avoided color organization and improvised palettes according to each painting's development. In art classes today, palette organization of some sort is standard instruction. Personality, purpose, and subject may influence selection. Ultimately, the content and organization of an artist's palette often reflect a personal color philosophy derived from experience.

PAST PALETTES

Throughout history palettes have been used very differently, reflecting distinct ideas about color and mixing. Artists in antiquity did not use palettes. They had few pigments, knew little of mixing, and applied color directly from separate pots. Aristotle's writings indicate his awareness that colors, when mixed, became corrupted. He thought pigments incapable of duplicating the beauty of nature. A legendary Greek painter named Apelles used only four colors, supposedly red, yellow, black, and white. His fame inspired color-mixing avoidance for centuries after. Interest in mixing evolved gradually, along with expanded availability and knowledge of color.

Renaissance fresco painters had no need of palettes. Their plaster dried so fast that predetermined individual color areas had to be painted separately and applied immediately.

The quick drying time did not permit blending or introducing extra colors while working.

Contemporary accounts describe early-fifteenth-century Flemish palettes as paint-holders with no mention of mixing. In the following century Northern Renaissance artists began to mix colors but seemed to prefer glazing as the way to add and manipulate color. Some Italian Renaissance artists were known to keep a separate brush for each color.

Studies in optics and color logic during the seventeenth century changed artists' thinking about palettes. Different color systems emerged, prompted by growing interest in color theory. Palette handbooks prescribed organization. Edging the palette with a spectral sequence was common. A second row was created with neighboring color mixtures. Some liked to arrange colors according to value. Rembrandt kept a different palette for each part of a painting.

By the eighteenth century palettes became more complex. Painters (or studio assistants) set up elaborate premixed full-color palettes in tonal ranges. Such practices are still common among present-day traditionalists. Delacroix, the palette aficionado of his time, customized a different extensive palette for each painting.

Earth tones were standard fare on old master palettes. Many of their colors are now obsolete due to expense, instability, or health concerns. Vibrant colors available today were yet to be developed.

Nineteenth-century palettes became more individualized—some highly orchestrated—signaling growing ideological diversity. Traditionalists stressed mixing thoroughly to eliminate any hint of original pigment. Innovators preferred pure, unblended colors. Palettes became less tonal and more spectral, reflecting complementary or temperature awareness.

THREE FOR ALL

Limiting a palette to three primary colors is an approach held by purists, who think of it as logical rather than restrictive. A palette of primaries is practical in that only three colors are needed. Spaced apart on a palette, room is available for mixing other colors. White is an essential addition to lighten colors. Opinions differ on whether the best way to darken color is to use black from a tube or "black" from dark colors.

The drawback to a primary palette is that it is ideal, not real. Attempting to mix any and all observed or desired color from only three is futile. Pure primary colors exist only in theory, not in pigment, inevitably skewing colors they mix. Character variances (warmer or cooler, darker or lighter, brighter or duller, and hue bias) of any specific red, blue, and yellow will slant a painting's mood and meaning.

A palette of just three—a red, a blue, and a yellow—is nevertheless advantageous. Color kinship is a built-in unifying influence despite inherent color bias and consequent off-center mixtures. (See Sean Dye's *Lewis Creek Road* on the next page for an example of a unique primary palette approach.)

Color dominance—when one portion of the palette is excluded in favor of another—may easily be adjusted in a palette of three basics. If one primary is used only with additions from the other two primaries, that primary and its color offspring become subordinated by default. For example, red and blue in small additions dull the yellow source on the palette. Any color mixed with that yellow is further subordinated by colors mixed with either red or blue. As a result, violets will dominate due to higher red and blue content. Any color containing the reduced yellow will not be as vibrant as the violets. A palette of three may shift dominance in a different way by subordinating a blue using red and yellow additions, keeping red and yellow saturated. The resulting dominant color then becomes orange.

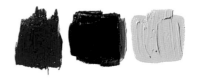
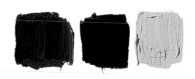
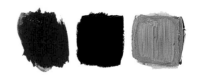

PRIMARY PALETTE WITH ONE SUBORDINATED. Top: blue subordinated with additions of red and yellow; center: red subordinated with additions of blue and yellow; bottom: yellow subordinated with additions of red and blue

IN THE STUDIO: ABBY LAMMERS

ABOUT THE ARTIST

Abby Lammers launched her painting career in 1994 after thirteen years as an advertising art director. Her widely awarded work has been exhibited in group and solo shows in museums and galleries throughout the United States, including shows held by the American Watercolor Society, National Society of Painters in Casein and Acrylic, Watercolor USA., and The Butler Institute of American Art.

Lammers is a Signature Member of the Transparent Watercolor Society and the National Watercolor Society. Her work has been featured in several magazines, including *Art Calendar*, *Art Business News*, *The Artist's Magazine*, *American Artist* magazine, and *Watercolor Magic Yearbook*, and in the books *New Art International* and *Encyclopedia of Living Artists*. Lammers maintains studios in Rochester, New York, and Falmouth, Massachusetts.

COLOR PREMISE

Abby Lammers's paintings are at once by the book and off the charts. Relying on design for structural foundation, she is attracted to "shape, form, space, and the formation of other shapes determined by how light strikes the subject."

Her images are representational in that they depict accurately proportioned recognizable places. However, her unexpected color combinations cause the viewer to reconsider everyday scenes and objects. Mining traditional color theory, commercial and natural color occurrence, Lammers will "try just about anything" when exploring color solutions.

Lammers's approach evolved from an early concern for capturing local color realistically. Andrew Wyeth inspired her appreciation for value. Jack Beal, Richard Diebenkorn, Janet Fish, Sondra Freckelton, Winslow Homer, Edward Hopper, Fairfield Porter, Wayne Thiebaud, and N.C. Wyeth influence her focus on color and composition.

COLOR METHOD

Abby Lammers makes extensive preliminary studies to familiarize herself with a subject. She repeats composition in different media and color, looking to "create a fresh look in each." After doing a thumbnail sketch she moves to value studies. Her first painted executions, involving local colors and basic mixing theory, confirm composition, perspective, and value distribution. To create atmospheric perspective, she adjusts foreground colors to be brighter and darker, and the background colors grayer and lighter.

ARTIST'S PALETTE

Abby Lammers's watercolor palette represents various manufacturers. While Winsor & Newton is her primary choice, she also enjoys Holbein Artists' Water Colors and some from M. Graham & Co. Her palette, in color wheel order, is: Cadmium Lemon, Winsor Yellow, Aureolin, Gamboge Genuine, Cadmium Yellow Deep, Cadmium Orange, Cadmium Scarlet, Cadmium Red Deep, Winsor Red, Permanent Alizarin Crimson, Permanent Rose, Rose Madder Genuine, Permanent Magenta, Cobalt Violet, Winsor Violet, French Ultramarine Blue, Cobalt Blue, Cerulean Blue, Phthalo Blue, Cobalt Green, Phthalo Green, Viridian, and Permanent Green.

When using acrylic paints, Lammers prefers acrylics from Golden Artist Colors "for their color range." Also included are a few M. Graham & Co. pigments admired by Lammers for "smooth consistency right out of the tube allowing for easy thinning and mixing." A traditional palette setup is not needed since she mixes colors as needed in plastic cups. Her favorite acrylics include: Hansa Yellow Light, Cadmium Yellow Dark, Nickel Azo Yellow, Cadmium Orange, Transparent Pyrrole Orange, Cadmium Red Medium, Naphthol Red Medium, Quinacridone Red, Dioxazine Purple, Anthraquinone Blue, Ultramarine Blue, Light Ultramarine Blue, Phthalo Blue (Red Shade), Cerulean Blue, Cobalt Turquoise, Turquoise (Phthalo), Phthalo Green and Titanium White, all Golden Acrylics, along with Cadmium Red, Permanent Green Light, and Cobalt Blue, from M. Graham & Co.

Lammers's watercolor palette. Wells surrounding a mixing space contain twenty-four different colors arranged in color wheel order.

Lammers's acrylic palette. No space is provided for mixing. Premixed colors held in plastic cups are arranged in sequential rows.

Her intuitive approach, focused on personal interpretation and curiosity, shifts to "brighter alternative relationships." She may ask, "What if? What if the sky was red and the grass orange? How would that affect the rest of the piece dimensionally, emotionally, or spatially?" Her somewhat arbitrary initial choices experiment with color temperature and intensity, which then drive subsequent color applications, often evolving through a full palette, while avoiding black. She explains, "What I do feels intuitive but it is in fact based in formal academic structure and on testing textbook color harmonies and principles such as simultaneous contrast."

STUDIO PRACTICE

Having determined her composition/color value "plan of action," her drawing is transferred to paper or canvas and sprayed with fixative. Abby Lammers prefers water media, using watercolor or acrylics, sometimes in combination.

She keeps a water spray bottle handy to maintain liquid consistency for both watercolor and acrylics. Acrylic color mixtures are kept in separate plastic cups, rubberbanded with clear plastic. While preferring to premix colors, she is not opposed to using them straight from the tube.

Working watercolors light to dark, Lammers likes to "minimize any hint of brush strokes." She applies color either by glazing over dry color or painting into still damp areas. "Colors mingle and produce some beautiful combinations useful for reflected light and foliage textures," she notes. Conversely, Lammers works her premixed acrylic colors from dark to light. Finding acrylics "more forgiving," she tends to work them more freely.

Lammers demonstrates her color-searching process in the development of a watercolor painting. She chose a three-primary palette for predetermined interpretation and color dominance. Value contrast, established early on, guides color value judgment thereafter.

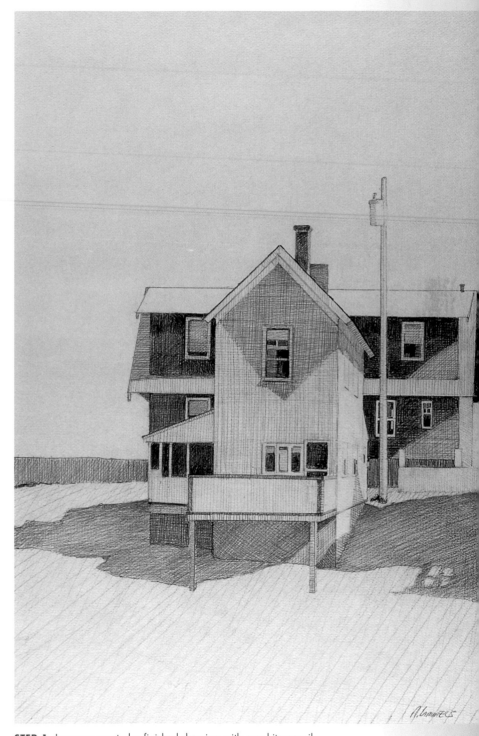

STEP 1. Lammers created a finished drawing with graphite pencil.

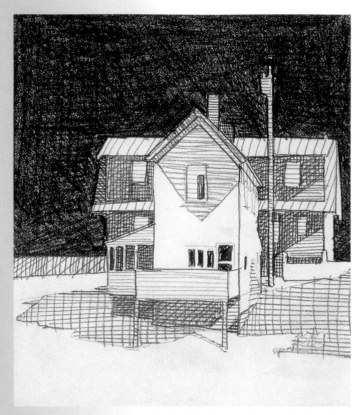

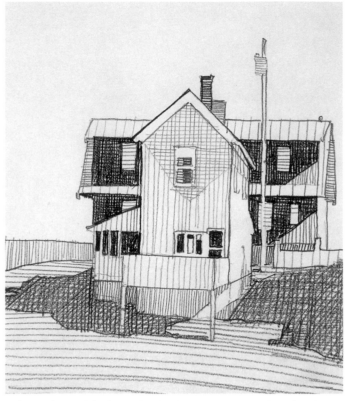

STEP 2. *Value Study A.* From the finished drawing the artist developed four thumbnail value sketches.

Value Study B. Of the four value sketches, this one was selected as the value pattern for her painting.

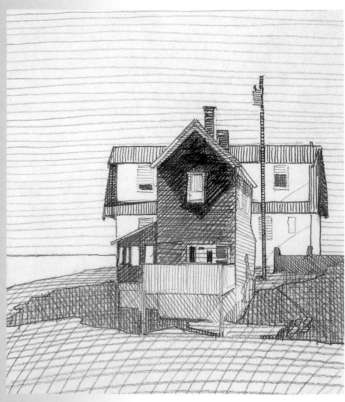

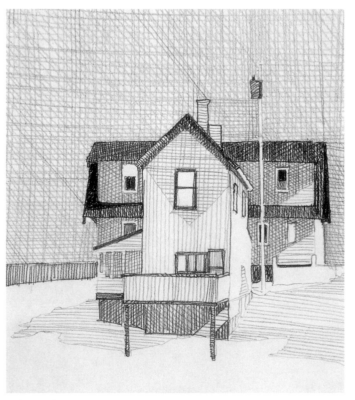

Value Study C

Value Study D

STEP 4. A French Ultramarine Blue wash on dampened paper indicates sky.

STEP 3. *Triadic Color Chart.* Lammers's limited palette: Cadmium Lemon, Cadmium Red Deep, and French Ultramarine Blue. She often charts colors for mixing reference.

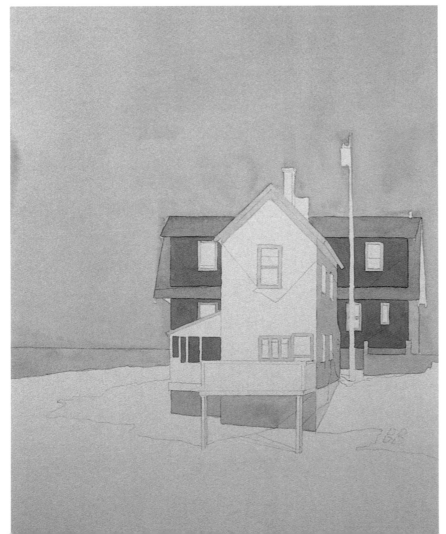

STEP 5. *Warm dominance plan.* Cooler, muted background colors, and warmer, brighter foreground ones suggest atmospheric perspective. A French Ultramarine Blue and Cadmium Red Deep wash is used for the ocean, wall, and house foundations and a medium-valued Cadmium Red Deep wash for the body of the house. A French Ultramarine Blue/Cadmium Lemon wash darkens and warms. A Cadmium Lemon with Cadmium Red Deep wash is for the house's sunlit side in the foreground.

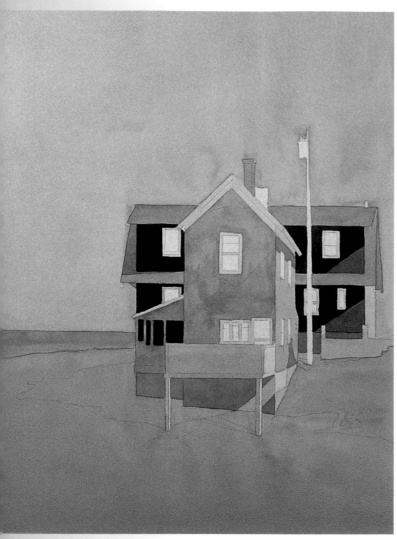

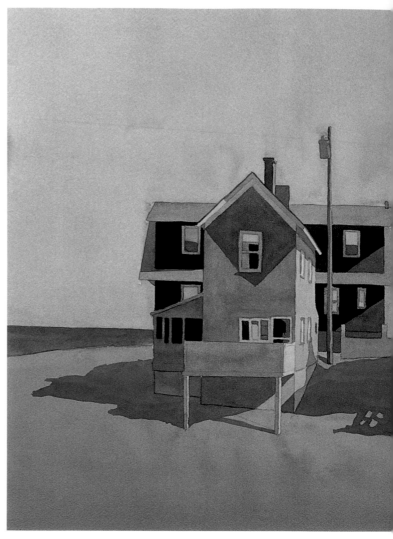

STEP 6. On damp paper a Cadmium Lemon and Cadmium Red Deep mix is used to create a warm grassy foreground. A red-orange mix of Cadmium Red Deep and Cadmium Lemon add foreground. The darkest value, a Cadmium Red Deep and French Ultramarine Blue, forms the background house shadow.

STEP 7. A darker glaze of Cadmium Red Deep and Cadmium Lemon improve the foreground house shadow. Slightly neutralized French Ultramarine Blue adds foreground contrast. Cadmium Lemon plus Cadmium Red Deep, neutralized with a touch of French Ultramarine Blue, create a cast shadow. Color repetition adds harmony.

COLOR CONCLUSIONS

Abby Lammers strives to "forever be a student." Fine-tuning her craft, she says, is "an ongoing, exciting, frustrating, and an overwhelming process when you realize how much you don't know." The artist attributes equal importance to formal education and hands-on experience, recommending study of "color theory along with works of the masters" as essential to developing personal style.

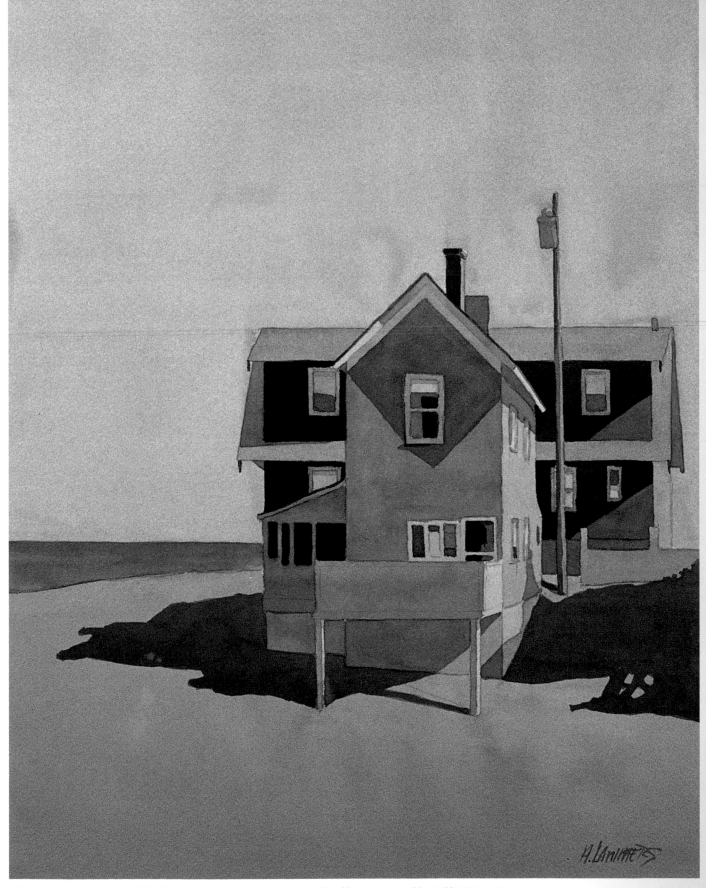

Abby Lammers. *Space Invasion*. 2003. Watercolor on 140-pound Arches Aquarelle cold-press paper, 14⁷/₈ × 11⁵/₈" (37.8 × 29.5 cm)
Collection of the artist

FINAL STEP. A glaze of Cadmium Lemon, Cadmium Red Deep, with a touch of French Ultramarine Blue, completes foreground shadows. A few heavier glazes add dark detail accents.

IN THE STUDIO: CAMILLE PRZEWODEK

COLOR PREMISE

Camille Przewodek describes the source of her motivation: "My creativity centers on excitement over light as it falls on the landscape at specific times of the day and under specific conditions. My use of color is inspired by color relationships perceived under many varied light schemes. Light itself becomes the subject matter and carries the painting. Artist Charles Hawthorne said, 'Anything under the sun is beautiful if you have the vision. It is the seeing of the thing that makes it so'."

Przewodek recommends *Hawthorne on Painting*, a book about Hawthorne's insights on color seeing. Studying directly under Henry Hensche, himself a pupil of Hawthorne, connected her to Hawthorne's wisdom and opened her eyes to a new way of seeing. Przewodek's use of color adheres primarily to Hawthorne's teachings. However, she also sees strengths in artist Sergei Bongart's spontaneous approach, and her work shows influence from both Bongart and Hawthorne.

COLOR METHOD

Camille Przewodek cannot stress enough the importance of a strong start in painting. Initially, she looks at a scene as a broad pattern of flat color shapes and quickly puts down the big masses, using different colors to distinguish between light and shadow. She keeps all the sunlit colors close together in value (light) and all the shadow colors together in value (dark). Following this logic, Przewodek notes, "A white in shadow would be darker than a black in sunlight. However, this is not always the case." Relying on direct observation, she tries not to paint theoretically.

When starting a painting, Przewodek applies a thinly brushed "lay-in" and eventually works up to thicker applications with a painting knife. Przewodek rarely uses paint right out of the tube, and instead prefers mixing colors on her palette. That said, her "most accurate color refinements—such as shifting temperature or changing the color slightly—are made by mixing directly on the painting surface. Indian Yellow, for example, is transparent and very useful for warming something up without completely altering the color and value in the way Cadmium Yellow Deep does."

She aims next to paint color changes within the big masses, keeping the integrity of her strong start. Przewodek uses color to build form. "Instead of drawing objects round I create roundness with color changes," she explains. As a colorist, she has "only pigment to suggest the effect of light." In full sunlight, for example, instead of local or actual color, Przewodek attempts to paint the effect of light on that object. She "might use a yellow or pink to begin a blue in full sunlight, or the shadowed side of a white building could be stated with violet." Her focus is to "paint the various light keys of nature ranging from gray to sunny days."

Przewodek claims, "Painting is like juggling. As I put one color down, I relate it to all the other colors in the painting." She "pre-visualizes" darkest dark and lightest light placements before picking up a brush. "The trick is to not think of colors in isolation, but rather like notes in a chord and evaluate each color in relation to all the other colors," explains the artist.

STUDIO PRACTICE

Camille Przewodek, who paints with both knife and bristle brush, cites "painterly qualities" as one reason she prefers oils to other painting media. She explains, "Oils do not dry fast like acrylics, so I can add colors to the initial statement without completely having to remix color."

She often uses Gamblin's Galkyd or Liquin alkyd painting medium "for shine and to speed drying time." Przewodek prefers the consistency of Winsor & Newton paint, explaining,

Colors are arranged in the order of the spectrum, segregating exceedingly strong tinting colors such as Phthalo Blue and Dioxazine Purple, to be used sparingly. To free up her mixing surface and allow for its easy cleaning, pigments are held vertically on a separate metal clip on the palette. This metal palette fits into a holder for convenient transport.

"It is less oily than some other brands." (Excess oil could cause paint to slide off her vertically angled palette.) She finds Winsor & Newton's Indian Yellow superior to others, and has favorites among other makes, including Sevres Blue and Caput Mortuum Violet from Rembrandt.

Through color mixing experience, Przewodek recognizes inherent warm or cool leanings of her primaries. She knows what to expect from specific mixtures. Using the six basic colors, she notes, "A pure purple can be made from Permanent Alizarin Crimson and Ultramarine Blue. These two colors share the cool red and there is no yellow in either of them to neutralize the purple. However, at times when a grayed-down purple is needed, Cadmium Red and Ultramarine Blue can be mixed. The orange in the Cadmium Red will neutralize the blue."

Through methods emulating those practiced at the Cape Cod School of Art, where she studied with Henry Hensche, Przewodek provides insight into her color thinking through a still life painting demonstration.

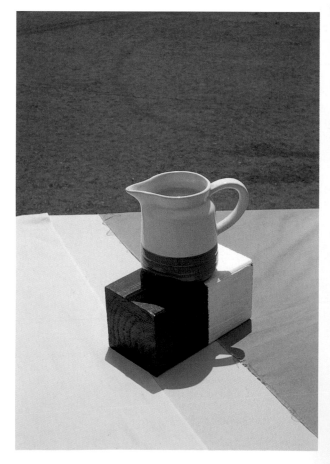

PHOTO OF STILL LIFE. The cloths are light versions of the three primary colors. Przewodek created the black and white block to show how value differences behave in light and in shade. The pitcher provides an opportunity to compare its warm white with the cool white on the block.

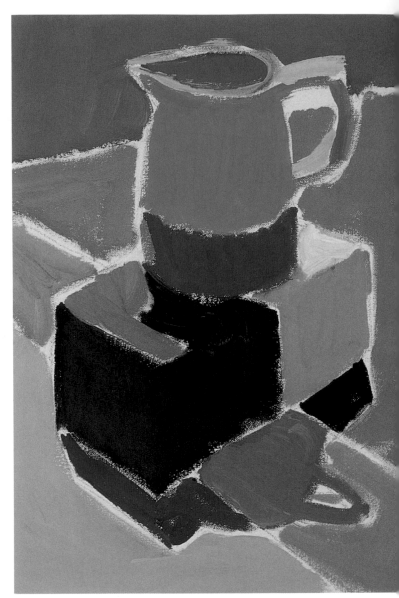

STEP 1. Przewodek begins with a simple block-in drawing. She uses a light blue Conte pastel pencil because it is easy to erase if revisions are needed. She "never uses graphite or charcoal since they will dirty the color."

STEP 2. The first statement of big color masses is made. The inside of the pitcher is started with a color that was warmer and darker compared to the white on its outside, which is started with a cooler and lighter blue. She took care to "keep all the light planes within the same general value range, and all shadow planes within a distinguishably darker value range." Note that color areas do not touch each other.

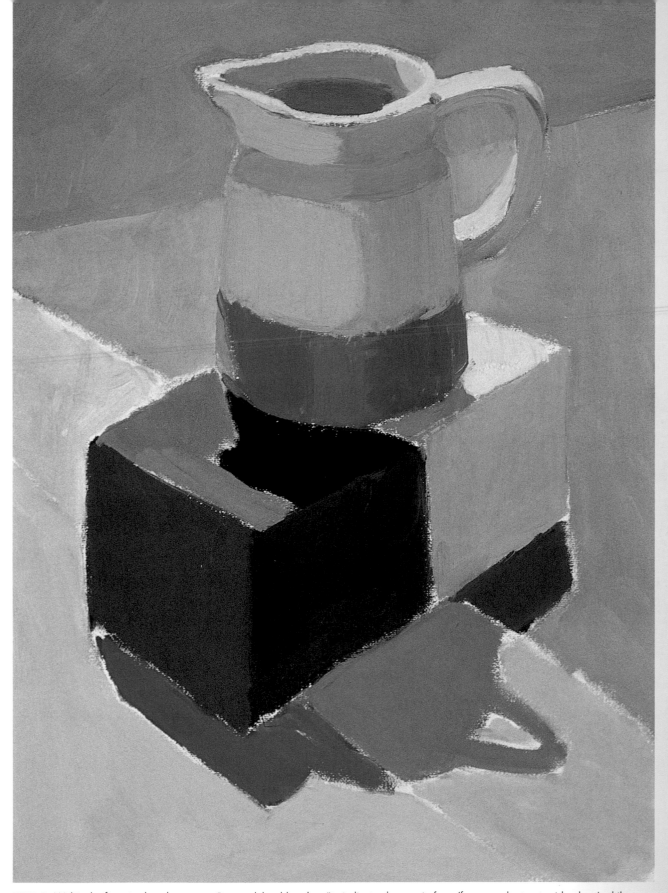

STEP 3. Within the first simple color masses Przewodek adds colors "to indicate changes in form (for example, top to side plane) while maintaining accuracy of the color relationships already established." She realizes the need to "make sure the white in shadow remains dark enough in value to stay in the shadow." She also makes color changes to the sides and top of the block, to show color reflected from the cloth and the sky.

COLOR CONCLUSIONS

Camille Przewodek warns against over-reliance on formulas: "Work sincerely and directly from nature as much as possible. When you set up on location, look to nature and discover what it has to offer; pretend you are a visual virgin. At the start, the authoritative first statement of big color notes is the crucial foundation of a painting. When I paint full sunlight, I always exaggerate the light's warmth. I try to start a painting with vivid color, since it is much easier to later reduce intensity than to make a neutral color pure. The beauty of a color is determined by colors around it. A neutral color properly related to its neighbors will sing next to a pure color, but next to another neutral, it may look muddy. So, it isn't the individual color that's important; it's relationship to other colors in the painting."

Przewodek also recognizes the value of drawing and composition along with painting rudiments as essential fundamentals for painters: "Every successful painting is built on good abstract composition. Lack of knowledge about paint and applying it can get in the way of discovery. Once you have grasped basic painting mechanics, you will be able to express your unique vision. If you are excited about what you are painting, you will inspire others. Find a master painter to be your guide. Find someone who will inspire you on your journey to becoming a great painter."

STEP 4. Now confident of the established masses, she starts to put in more reflective light. She is careful to "keep the reflective light dark enough to stay within the value of her shadow mass." Przewodek now adds some local color, again maintaining the general value and reintroducing some of the warm color of her first color statement. She also puts darker core shadows on the handle of the pitcher.

Camille Przewodek. *Still Life*. 2003. Oil on gesso-primed cotton, 15 × 11" (38.1 × 27.9 cm)
Collection of the artist

FINAL STEP. Adjustments bring colors closer to their local color while still maintaining the effect of light. Przewodek finishes with more reflective light added under the pitcher spout.

Though how we perceive and respond to color is affected by universal psychological associations (for example, orange = warmth/excitement; blue = coldness/calm) and basic visual tendencies (for example, warm colors advance; cool ones recede), color is ultimately a highly personal experience. Neither color wheels nor wavelengths can define how we actually see and react to colors anymore than they can precisely specify color mixtures. The challenge artists face in each work is imparting, if only in part, *their* experience by guiding viewers' perception and emotional response.

Knowledge of color and how it behaves—along with understanding how the brain perceives reality—are basics of artists' trickery. To represent two-

LIGHT

50%

DARK

COLOR VALUE WHEEL MADE WITH COLOR-AID PAPER. Yellow and violet are the polar extremes in value. Red and blue are similar in value. The 50 percent dark/light line illustrates that the majority of colors present lighter value levels. Combined, however, lighter colors' values become quickly overshadowed by the darker values of colors with which they are mixed.

COLORS IN CONTRAST

dimensionally their reactions to three-dimensional views of life around us, artists must lie to tell the truth. In real-life observations, the brain deciphers depth primarily by assessing dark/light differences and comparing left-eye/right-eye binocular views. In paintings, artists count on aspects of color other than value to compensate for the actual flatness of depth illusions.

Leaning on the mid-twentieth-century codifying treatises of Johannes Itten and Josef Albers, and contributions of artists such as Hans Hofmann, who turned "push" and "pull" into standard references for visual color movement from the picture plane, artists come to recognize that color can influence visual and psychological perceptions. And, over time, they come to understand that in painting practice individual color theories must often either be broken or adjusted to work compatibly with coexisting theories.

VALUE

A COLOR'S RELATIVE lightness or darkness determines its value. A lighter color is often described as "higher" in value and a darker one as "lower." White is the pigment closest to full light reflection, black the pigment closest to full absorption. In scientific discussions of color and light, the terms *value* and *intensity* refer to the same characteristic of brightness (reflective level). (Note: The use of these terms can vary according to *who* is using them and in what context. Artists use the term *intensity* in describing the degree of color saturation, which scientists call *chroma*. Artists use the term *value* in describing a color's lightness or darkness, whereas scientists think of lightness in terms of luminescence and often call it *intensity*.)

Some colors are naturally darker or lighter than others. Regarding spectrum value, *lightest* is the level where a color is at full intensity—that is, at its most light reflective. Yellow is typically the lightest color. In pigment and in light, complements yellow and violet represent value extremes, regardless of value inconsistencies between pigment versions. Orange and green share similar light levels, slightly darker than yellow. Red and blue tend to be of mid-range value. (See illustration on opposite page.)

JUDGMENTS

Mixed with achromatic white or black, a color's value changes without altering its hue. A *tint* results from mixing a color with white to make it lighter, a *shade* from mixing with black to make it darker. Stronger doses of white are required to lighten than of black to darken. How much of either depends upon the natural value level of the color being lightened or darkened. Generally, less black is needed to darken a light color like yellow; more white is needed to lighten a dark-value color like blue. With transparent media like watercolor, color is dark until diluted, and so is lightened by adding water. However, adding white or black to a color takes away from the color's intensity; white fades color, black deadens it.

COLOR-VALUE COMPARISON. Left: Swatches of red, blue, and yellow paints selected as primary colors and their secondary mixtures are aligned according to value. As usual, violet (Crimson Lake mixed with Cobalt Blue) is darkest and yellow (Permanent Yellow Light) is lightest. The red (Crimson Lake) is a little darker than this particular blue (Cobalt Blue). Another blue might be a little darker, another red a little lighter. Mixed secondary colors reflect the characteristics of their parent colors. (Holbein Artists' Oil Colors); Right: A grayscale version of the same color swatches proves their dark and light differences. Its dark-to-light gradation confirms the appropriateness of their arrangement.

Anyone who has been to art school is probably familiar with Color-aid papers, widely used in color theory instruction. Its color notation system indicates specific hues by name (H), tint (T) or shade (S) level, lightness (L) or darkness (D), both black and white content (P), or grayscale position. Hue tints in Charts 1 and 2 illustrate uniform change with each step. Note the varied number of tint steps between hues of naturally different value. Yellow is lightened by only two tint steps while blue-violet, a much darker color, is lightened to an equal extent by five tint steps.

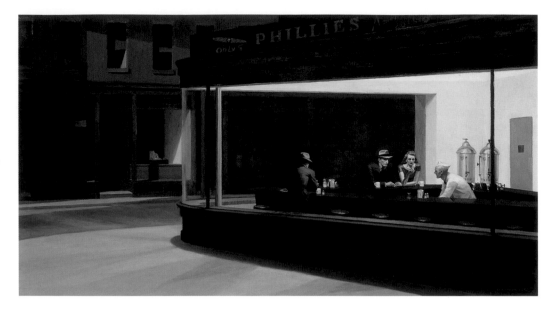

WHAT IS IT WORTH? Color plays a supporting role in Edward Hopper's (1882–1967) dramatic values. Hopper simplified form, reduced detail, and weeded out clutter, so as not to detract from lighting. Like his Baroque mentors, he heightened the importance of light by increasing shadow proportions.

Instead of using black or white, a color's value may be altered by mixing it with a color darker or lighter than itself. Yellow, for example, due to its inherent lightness, may be darkened by just about any other color. However, beyond just making it darker, the choice changes yellow's appearance. Mixed with red, yellow becomes warmer, darker, and more orange. Blue makes yellow cooler, darker, and greener. Mixed with violet, yellow turns darker and, because they are complements, duller. Each color brings its own characteristics to the mix.

WHAT IS IT WORTH?

Value is a color quality, separate from and irrelevant to intensity and temperature. The eye perceives value differences first (luminosity), before registering specific color, a perception trait that goes back to basic instinct. In nature, survival often depends upon the ability to recognize things quickly. When there is insufficient light to discern color, we can still make out forms from their light reflections. In the animal kingdom all mammals see in black and white. Only primates have evolved to see full color.

Value is most valuable in visual art for attracting attention or defining form and space. Dark/light contrast extremes shock the eye. Both black and white can fatigue vision, causing reverse afterimages. Either can easily dominate a color composition. John Ruskin's caution, "Use

them little, and make of them much," speaks to the power of black and white even in small doses.

A color's value is more significant than its other characteristics—temperature, intensity, or even hue. If an image's value distribution is appropriate, dark and light in the right places, it matters less what colors are used. My round red figure series on the opposite page illustrates the importance of value over color in creating a sense of form and space. In the first image the red figure is nothing more than a flat disc floating on a black field. Yet red's visual aggression reads as a positive thing against black negative space. In the next image, the black changes to gray below and white above. Since the red disc overlaps the boundary between them, the white and gray shapes read as foreground (lower) and background (top). A black outline flattens the red disc, confusing depth illusion, yet it distinctly separates it from the background. In the third, a light source is implied with black/white value gradations and the red shape finally becomes spherical. A black cast shadow on gray ground suggests that the ball is on surface. An undefined blurred edge replaces black outline creating a more realistic representation of binocular vision. The red ball needs no other colors in order to look three-dimensional. Even then, represented in full palette, color values align appropriately to maintain depth illusion.

Caroline Jasper. *Red Round Series, #1*. 2002. Acrylic on gessoed watercolor paper, 14 × 11" (35.6 × 27.9 cm)

Caroline Jasper. *Red Round Series, #2*. 2002. Acrylic on gessoed watercolor paper, 14 × 11" (35.6 × 27.9 cm)

Caroline Jasper. *Red Round Series, #3*. 2002. Acrylic on gessoed watercolor paper, 14 × 11" (35.6 × 27.9 cm)

Caroline Jasper. *Red Round Series, #4*. 2002. Acrylic on gessoed watercolor paper, 14 × 11" (35.6 × 27.9 cm)

POSITIVE/NEGATIVE PERCEPTION (VALUE ONLY). Black areas visually project in both images, regardless of proportionate space. Left: The centered white block visually recedes within black surroundings; right: White reads as background behind a black square.

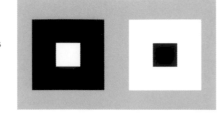

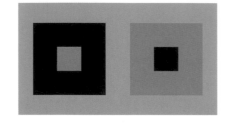

POSITIVE/NEGATIVE PERCEPTION (COLOR VALUE: DARK BLUE/LIGHT RED). Color value counts for more than color temperature. Generally, warm colors tend to visually project; cool colors tend to visually recede. Blue, however, becomes the forward-projecting color when coupled with a pale red, regardless of size relationships.

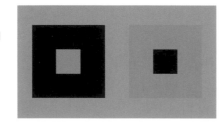

POSITIVE/NEGATIVE PERCEPTION (COLOR VALUE: DARK RED/LIGHT BLUE). Red's natural visual projection is enhanced when deepened to darker value, either placed around or against a blue lightened and thus made to recede more distinctly.

Light versus dark in various proportions can imply positive/negative space. White on black expands; black on white contracts. Color values relate in much the same way. Colors' relative darkness or lightness makes a stronger visual impact than do their relative warmth or coolness, brightness or dullness.

Artists often make value studies in black and white before starting in color media. Beginning a work with a monochromatic value-gradation underpainting is another alternative. Compare Sean Dye's first treatment in values with the finished painting built over it. Such preparation reduces the subject to its most essential dark/light elements, providing the artist a preview of the impact of the whole image.

THE VALUE OF EACH COLOR

A color's value is important in relation to others used with it. Charting color for value comparison helps in planning appropriate use.

Sean Dye. *Love, Death, Hope and Faith Take a Walk in Provincetown,* underpainting. 2003. Acrylic gouache on panel, 15 × 30" (38.1 × 76.2 cm)

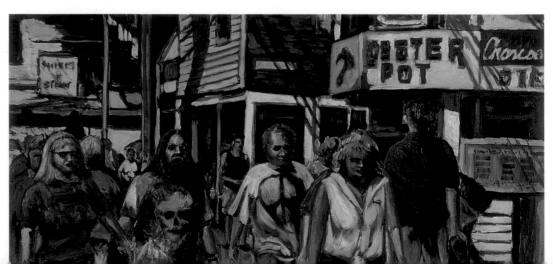

Sean Dye. *Love, Death, Hope and Faith Take a Walk in Provincetown.* 2003. Water-soluble oils, egg tempera on panel, 15 × 30" (38.1 × 76.2 cm)
Collection of the artist

Darkest and lightest are easy to identify. Mid-range value colors are usually more difficult to chart. Their inherent intensity and temperature differences can confuse efforts to see them in terms of value only.

Colors may be selected strictly for value, ignoring hue and other characteristics. Any full-color image converted to grayscale underscores the significance of value over color. In my full-color orange slice study it is less obvious that the colors used are value-conscious because they adhere to local color. Reduced to gray scale, the importance of each color's value is more apparent. Light and shadow read as such because each color is value appropriate.

Caroline Jasper. *Color Value Study (color)*. 2003. Oil on paper, 6 × 8" (15.2 × 20.3 cm)

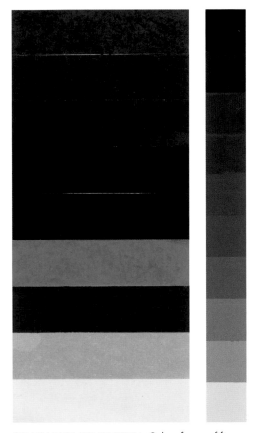

COLOR-VALUE COMPARISON. Colors from a fifteen-color set of Holbein Artists' oil pastels align for value comparison. Orange and green in the example are very similar in value. The orange's brightness and the green's relative coolness obscure judgment. Media transparency or opacity affects appearance as well. (The orange is more opaque; the green semitransparent.) Green in solid stick form looks darker than orange. Once applied to white paper it appeared lighter because of its relative transparency.

Caroline Jasper. *Color Value Study (grays)*. 2003. Oil on paper, 6 × 8" (15.2 × 20.3 cm)

VALUES IN DEPTH

Seeking a formula for distance value, students often ask, "Should the background be dark?" or "Should the background be light?" Either can work. It depends on the location of the light source. An overhead source flattens a subject with even lighting. Back, frontal, or side lighting sources all create shadows, enhancing a three-dimensional look.

Value contrast—light against dark—is what makes the foreground visually stand out. This is most effective if the background lacks value contrast. Monotones (all dark, all light, or all gray) visually recede, a concept applicable to color since each has an inherent value. A color may also be darkened or lightened to make its value suitable to any depth placement.

Camille Przewodek brings a full palette to *The Jogger* but relies on value contrast to establish depth. Distinctly different dark-, medium-, and light-value zones define the foreground trees, mid-ground beach, and background landmass. Flashes of brilliant yellow and white within dark foliage confirm the palms' nearness. The

artist observed, "The atmospheric perspective of the mountain and water in the background of the Laguna Beach painting have a magenta cast, which keeps them in the distance. The palm trees, though in shadow, are brought forward by their colors' intensity and value."

A small building jumps out to grab attention in Bill James's *Little White Shack*. Despite a large centrally positioned bold green shape (tree), the smaller white spot (shack) stands out due to value contrast, yet holds its distant position within darker surroundings. Foreground colors look brighter compared to muted mountain hues. The artist notes, "This is a great example of aerial perspective . . . creating space by the use of color instead of line."

Glazing is a way to exaggerate value differences after a painting surface is dried to the touch. (Traditionally an oil painting technique, the glazing concept is applicable to other media as well.) A little touch of white mixed with oil medium, brushed over distant trees and hills, becomes an atmospheric haze pushing the background further away.

BELOW LEFT: The value pattern in Abby Lammers's *Rear View—Orange* was arranged with the sky lightest, foreground medium, and middle ground the darkest value. In a nearly monochromatic coloring, value contrast becomes crucial to establishing a sense of depth. Extreme dark/light differences on the building confirm its forward position.

BELOW RIGHT: In an alternative interpretation of *Rear View—Orange*, the value pattern reverses. The sky is dark and foreground light. Again, the building's extreme value contrasts keep it forward.

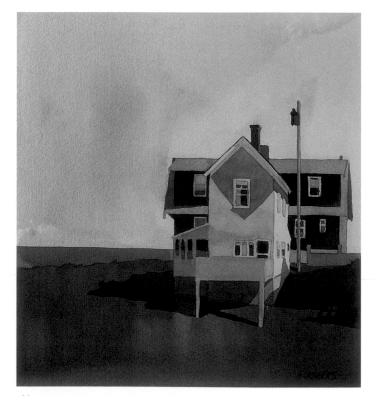

Abby Lammers. *Rear View—Orange*. 2002. Watercolor on 140-pound Arches Aquarelle paper, 10³/₈ × 9¹/₂" (26.4 × 24.1 cm)
Collection of the artist

Abby Lammers. *Nothing Sacred*. 2002. Watercolor on 140-pound Arches Aquarelle paper, 14⁷/₈ × 13" (37.8 × 33 cm)
Collection of the artist

Camille Przewodek. *The Jogger.* 2002. Oil on primed linen, 12 × 16" (30.5 × 40.6 cm)
Private collection

Bill James. *Little White Shack.* 2002. Pastel, 20 × 28" (50.8 × 71.1 cm)
Collection of the artist

(Most white paints are opaque or semiopaque, which adds to the haziness.) Substituting a transparent dark color in the glaze can conversely strengthen foreground shadows.

Glazing enhanced depth illusion in my *Past Presence*, magnifying foreground value contrast and subduing background contrast. Background trees and distant landmasses, already dull gray-blue, were covered with a thin coat of milky white poppy seed oil glaze. The foreground, already dotted with touches of pure white or yellow in the darkest shadow areas, was strengthened with a dark glaze in specific areas. Shadows gain depth and presence under a transparent glaze of Ultramarine Blue. The painting was started on a medium-valued red ground (color gesso), which provided value, temperature, and complementary contrast against many colors used in the painting.

Subject matter influences Sean Dye's depth-by-contrast methods. His *Taos Truck* colors are generally muted throughout. Subdued contrasts push the buildings back, while value and color contrast together pull the truck forward. Dye started with a dull yellow watercolor wash. After applying the truck's Ultramarine Blue, Burnt Sienna, and Sepia he misted dark airbrushed sprinkles to characterize its age and condition. Gouache layers increased the color intensity of its rusted surface. While characterizing subject matter, such applications also added variety to the foreground values.

Entering Carson National Forest, NM offers another challenge. Dye noted that the colors in the arid New Mexican landscape were unfamiliar to his works of the Northeast. "It was a real treat for the eyes," he recalls, "and fun to work with so many neutrals, especially the earthy reds, which are very hard to find where I live." The painting's "slatey" dark blue mountains contrast both sunlit sky and warm oranges in the foreground. To compensate for color contrast at the horizon, Dye dramatized value contrast in foreground details with strong shadows and highlights on fence rails and in grasses.

Caroline Jasper. *Past Presence*. 2000. Oil on canvas, 30 × 40" (76.2 × 101.6 cm) *Private collection*

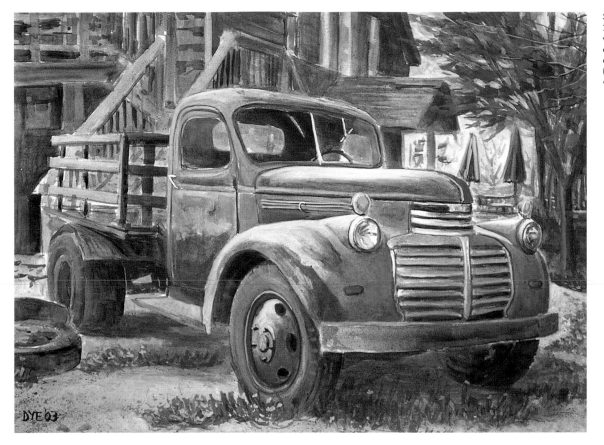

Sean Dye. *Taos Truck.* 2003. Gouache, watercolor, airbrush color, and graphite on paper, 20 × 28" (50.8 × 71.1 cm) *Collection of the artist*

Sean Dye. *Entering Carson National Forest, NM.* 2001. Oil pastel and watercolor on gessoed watercolor paper, 16 × 20" (40.6 × 50.8 cm) *Collection of the artist*

TEMPERATURE

A COLOR'S RELATIVE warmth or coolness defines its temperature, which in color is a perceived rather than literal characteristic.

SOME ARE HOT—SOME NOT

According to visual temperature readings, red, orange, and yellow seem warm. Blue and colors high in blue content seem cool. Orange and blue mark warm/cool extremes. Red and yellow, though both warm, can exhibit cool tendencies. Colors near blue look cooler with increased blue content. Neutral-temperature violet (blue/red mix) and green (blue/yellow mix) both have warm and cool content.

How color temperatures relate to one another is a major concern of artists. Context can embolden, dilute, or alter color temperature perception. By comparison, violet looks cool next to red, warm next to blue. Green looks cool next to blue, warm next to yellow.

Temperature appearance varies according to bias toward a parent color (determined by greater or lesser input from the parent color). All pigments have hue bias and therefore temperature bias as well. Thinking that red and yellow are always warm, for example, ignores character nuances affecting interaction with other colors. Some reds look cooler than others, as do yellows. While consistently cool, some blues look warmer than others. A blue could be biased toward either red (blue-violet) or yellow (blue-green).

In my warm/cool studies shown here, temperature theory dictated color choices for near and far areas. White subjects were placed in a white environment. Temperatures differ among greens in *Warm-Cool Study*. Fore-ground greens contain more yellow, the background greens more blue. The red color of the paper, concealed in the background, consistently peeps through to warm foreground temperature.

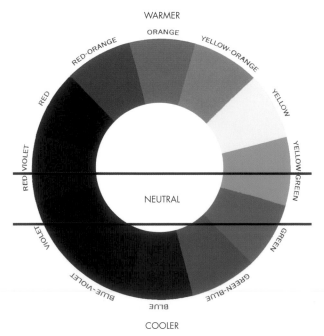

COLOR TEMPERATURE. This color wheel displays temperature gradations extending in either direction between orange (hot center) to blue (cold center). The green/violet temperature-neutral zone separates relatively warmer colors above, spanning yellow to red, from the cooler colors gravitating to blue at the bottom.

Caroline Jasper. *Warm-Cool Study*. 2000. Oil pastel on paper, 16 × 12" (40.6 × 30.5 cm)

Color Temperature Study offers a simpler variation. Greens are omitted in favor of stepping around the color wheel in the opposite direction. Foreground yellows and oranges transition to reds then violets, finally converting to all blue in the background. Note the inverted image of *Warm-Cool Study* in which value and color reverse. When color values and temperatures are inappropriately placed, form and depth become confused.

Warm and cool associations are learned. The physical and visual experience are joined when something feels hot and looks red or feels cool and looks blue. For example, a body chilled appears blue, flushed appears red.

There is more to color temperature than meets the brain. So-called warm colors, especially yellow, reflect more light. The physiological experience of light energy is greater in sunlight than in shade. Visual color perception can also induce psychosomatic response. Warm colors quicken circulation while cool colors have a calming effect. In a scientific study, workers compared their environment in contrasting visual temperatures. Walls were painted blue and then changed to red. In each setting, room temperature was reduced by degrees until subjects indicated feeling cold. In the red-painted room temperature went approximately 7 degrees lower before coldness was felt compared to sitting in blue surroundings. Red has a very different effect when lightened. Some law enforcement facilities unexpectedly have taken to painting their intake or interrogation rooms pink, creating a disarming environment in which violent tendencies quell and uncooperative attitudes yield. Familiarity with the psychophysiology of color temperature tendencies may guide artists in using color to sway interpretation.

Caroline Jasper. *Inversion of Warm-Cool Study.* 2000. Oil pastel on paper, 16 × 12" (40.6 × 30.5 cm)

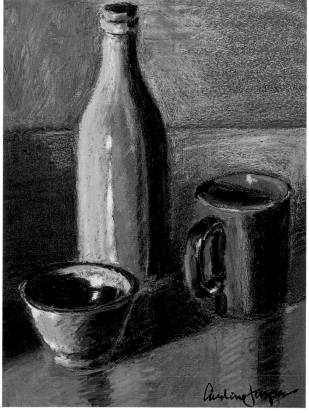

Caroline Jasper. *Color Temperature Study.* 2000. Oil pastel on Ampersand gray Pastelbord, 11 × 14" (27.9 × 35.6 cm)

DEPTH THERMOMETER

The visual phenomenon of color temperature is a mainstay of depth illusion in art. According to perceived temperature, colors visually project forward from the picture plane (agressive if warm) or retreat (calming if cool).

Color temperature depth implications have more to do with physics and physiology than with psychology. Various color wavelengths refract differently when passing through the eye's lens. The brain responds uniquely to each. Long-wavelength red, which refracts less, seems relatively nearer. Short-wavelength blue, in refracting more, delivers less impact. When gazing at red and blue in the distance, the eye is farsighted for red and nearsighted for blue. In a painting where red and blue have been applied to a flat surface, red appears closer than blue.

Camille Przewodek noticed, when painting *Fall Sky*, that vineyard grape leaves were turning a bright orange. She added warmth to the trees' shadows in the foreground to contrast with the cool sky. Background trees contain less color and contrast to make them stay in the distance. Deep, dark red trees edge the foreground. Further back, trees of the same type appear in faded violets.

In *Apples and Oranges*, Bill James sought "to paint fruit in a novel format and use complementary colors to make it more exciting." While concerned most with juxtaposing complements,

ABOVE: Camille Przewodek. *Fall Sky.* 2000. Oil on primed linen, 16 × 20" (40.6 × 50.8 cm)
Private collection

RIGHT: Bill James. *Apples and Oranges.* 1999. Pastel, 18 × 28" (45.7 × 71.1 cm)
Private collection

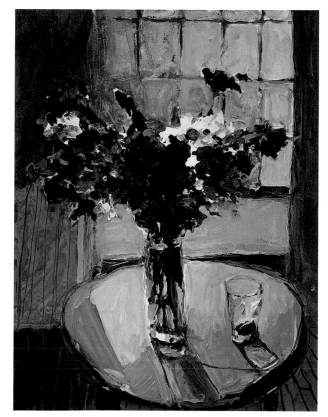

Sean Dye. *St. George Pond*. 2001. Water-soluble oil and acrylic gouache on panel, 16 × 20" (40.6 × 50.8 cm) *Private collection*

red against green and orange against blue-violet, James judiciously placed them according to temperature. In such shallow depth, the coolest colors occupy the table, including the bowl's deep purple shadow. Reds, oranges, and yellows cover closer fruit.

Sean Dye's *St. George Pond* knife painting is full of lush summer greens both near and far. A subtle warming shift of foreground greens emphasizes their closeness. Dye added red-violet splashes among earthy yellows reinforcing forward position.

Color for compositional emphasis, can be supported by temperature exaggeration. Red grabs attention. To emphasize the red flowers in *Sea Breeze Still Life*, Robert Burridge toned down and neutralized their surroundings with subtle cool grays. Additionally, the greatest black/white contrasts reside among the red blossoms and in the vase. Burridge enhanced depth with a temperature-appropriate pink tablecloth, blue floor, and blue-gray windows.

Robert Burridge. *Sea Breeze Still Life*. 1999. Acrylic on paper, 48 × 36" (121.9 x 91.4 cm) *Private collection*

Jeanne Carbonetti. *Window on Japan*. 2000. Watercolor on paper, 22 × 30" (55.9 × 76.2 cm)
Collection of Charles and Helen Damboski

BELOW TOP: Abby Lammers. *Cape Cottages, Yellow*. 2003. Casein on 140-pound Arches Aquarelle paper, 10¹/₈ × 12¹/₂" (25.7 × 31.8 cm)
Collection of the artist

BELOW BOTTOM: Abby Lammers. *Cape Cottages, Hull*. 2003. Casein on 140-pound Winsor & Newton paper, 10¹/₈ × 12¹/₂" (25.7 × 31.8 cm)
Collection of the artist

In abstract images, any sensation of depth relies completely on the visual *push and pull* of color. In the absence of subject matter viewers have only base elements to read the artist's intent, such as the temperature effects in Jeanne Carbonetti's *Window on Japan*. "White and yellow light hold the viewer steady while the planes rotate around it into ever-increasing coolness," says Carbonetti.

Abby Lammers changed palettes between two versions of *Cape Cottages*. A monochromatic interpretation favoring warmer hues in the yellow version is quite subdued next to the warm/cool dynamic in the "Hull" painting. Value similarities in the second painting tend to flatten depth, yet the building's hot red facade pops it forward against the cool sky.

In Kitty Wallis's *Water Lily #4*, a downward view of lilies floating on water presents a shallow depth of view in which water serves as background. Colors encompass the yellow to blue spectral sector with a few warm flower accents. Green's neutral temperature creates a middle ground of leaves against the blues of the water surface. Yellows emerge forward from the greens, adding three-dimensional qualities to the leaves.

COOL IN THE SHADE

Light and shadow effects may be enhanced through temperature-appropriate colors. In low light, long wavelengths (hot colors) seem to loose their ability to reflect. The retina's rod

and cone receptors have different sensitivity curves. Rods, which take over in dim light, have greater sensitivity to shorter (blue) wavelengths. Cones, which operate in daylight, are more sensitive to longer (red) wavelengths. Under low light, reds become less visible. All colors therefore look cooler in the shade. Everything seems to turn blue toward nightfall. As light fades blues appear lighter than reds whose value they match during daylight. On a clear day, a fence across a field of bright white snow casts an intense Cerulean Blue shadow. Later in the day, the same shadows look more like Cobalt or Ultramarine Blue. By using cool colors, artists give their shadows a more natural-looking appearance. In bright light, warm colors look more reflective than cool colors. Heating up the color of painted highlights may make them appear more vibrant and more convincing.

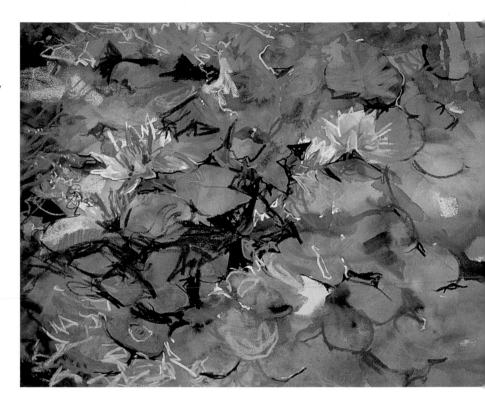

ABOVE: Kitty Wallis. *Water Lily #4.* 1986. Pastel on sandpaper, 22 × 30" (55.9 × 76.2 cm)
Private collection

LEFT: Camille Przewodek. *Point Reyes Way.* 2002. Oil on primed linen, 24 × 24" (61 × 61 cm)
Private collection

COOL IN THE SHADE. In *Point Reyes Way* blue fence rail shadows, which make for strong temperature contrast in foreground areas, repeat on distant rooftops and lead the eye back to an overall background coolness.

INTENSITY

INTENSITY describes color brightness or dullness compared to neutral gray. In scientific terms, "high" or "low" intensity pertains to a color's ability to reflect light. Intensity, or *chroma*, in pigment specifically refers to *hue* strength. That strength relies on "purity" and pigment saturation. A color is at its brightest and most visually powerful when straight from the tube, unmixed and undiluted. Hue reduction coincides with decreased intensity.

Color intensities naturally differ, evidenced by a quick glance at any open set of color pastels. At equal pigment levels, certain colors visually pop with brightness while others appear comparatively dim. A few exceptions include naturally dark-value colors whose hue identities magnify with the addition of either a little white (opaque media) or a little water (transparent media such as watercolor).

Saturation potential directly relates to how much pigment is in the paint. Tubes of paint from different manufacturers, labeled with identical name and pigment coding, may not exhibit equal brightness. Variance signals pigment percentage differences, milling methods, and perhaps differences in pigment quality as well. The brightest versions of any given color come from tubes containing the most pigment that has been thoroughly milled. Once milled, it must be mixed with the right amount of vehicle for good workability. Paints in which pigment is subtracted unnecessarily in favor of fillers suffer intensity loss as a result.

OPPOSITE EFFECTS

Complementary color is the key to intensity management. Each color requires its complement, either to be brightened or dulled. Unmanaged combinations can clash or turn to mud. When their natures are known, complements offer a broad range of effects.

Intensity (brightness/dullness) controlled by complements (Holbein Artists' Oil Pastels)

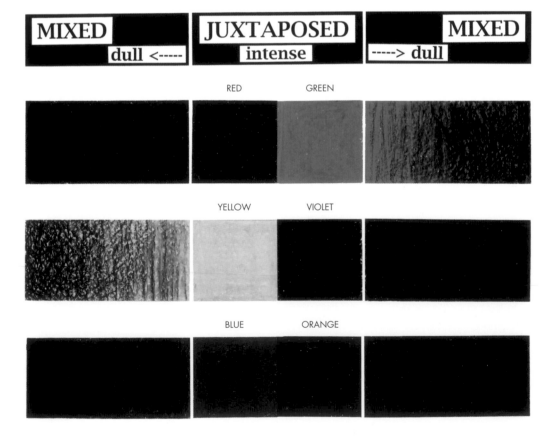

Pairing basic opposites illustrates how complementary colors affect intensity. A color is at its brightest straight from the tube, with one exception—any unmixed color juxtaposed with its complement looks even brighter. Mixing complements has the reverse effect. Each color is most effectively neutralized by its direct complement. Note tone similarities at the ends of the rows in the chart on this page and the opposite one.

BALANCE

Ancient Greek philosophy, revived during the Renaissance, holds that beauty, which was for the Greeks synonymous with balance, derives from mathematical order. Notions of visual balance in color evolved as light and optics knowledge advanced. Precise measurements, as with optical science, do not apply to pigment. Memorizing color-matching formulas does not guarantee color harmony. If the ancients were right, we seek balance in all we see. The eye satisfies the brain psychologically when it at once physically delivers all three primary colors. A visual yin/yang occurs between two dissimilar colors that together account for the entire spectrum. On a theoretical level, complementary color pairs make obvious examples: red + green (blue and yellow), blue + orange (yellow and red), yellow + violet (blue and red). In these examples each primary color is opposed by a secondary color, which is a blend of the other two primaries. Thus, each set of complements brings together all three primaries—in other words, all colors. The same is true of all pairs of complements around the color wheel.

Complementary color combinations naturally occur when opposing light sources interact. Warm-colored sunlight against cool blue atmosphere affect color differences in foreground and background. Interior yellowish light against cool daylight from a window can cast shadows complementary to each. Recording a color shadow that is complementary to light source color can add to the illusion of depth.

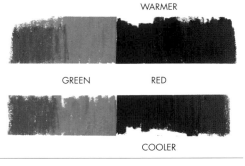

GREEN RED

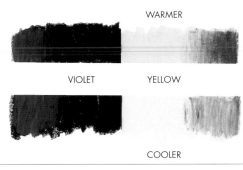

VIOLET YELLOW

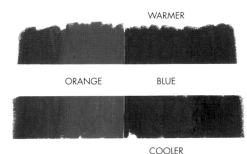

ORANGE BLUE

Intensity (brightness/dullness) controlled by various complementary matches (Holbein Artists' Oil Pastels)

DULL VERSUS DIRTY

There is a difference between dull color and dirty color. A color may be dulled without getting muddy if mixed with its true color complement. A mixture becomes dirty-looking when corrupted by the addition of other colors, the more the dirtier.

All red/green, blue/orange, and yellow/violet complementary matches are not equal. Since pigments are not hue balanced, mixtures between complements vary with color bias. The chart above illustrates green affected by warmer versus cooler reds, violet affected by warmer versus cooler yellows, and orange affected by warmer versus cooler blues, the latter having little or no bias. Complementary juxtapositions are more vibrant between those of greater polarity, especially when their values are similar.

Simultaneous contrast = visual vibration. Cerulean Blue Hue on red ground made of Orange mixed 50/50 with Carmine (Holbein Artists' Oil Colors and Holbein Color Gesso)

No vibration from color on white. Cerulean Blue Hue on white gesso ground (Holbein Artists' Oil Colors)

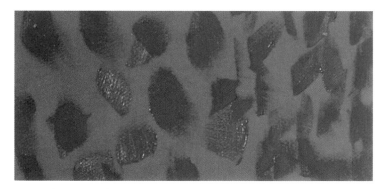

Grayscale version of Cerulean Blue Hue on red ground

The degree to which mixed colors dull relates to color wheel positioning. Closer together, colors are less likely to dull because of common content. Further apart, they differ more, increasing dulling. Intensity drops quickly when directly opposite colors mix.

Mixing opposites supposedly results in "perfectly" neutral gray. That happens only in theory because pigments do not match up as exact opposites. Hue bias always spoils perfection in their polarity. Consequently so-called complementary mixtures on the palette may look muddy instead of dull. The more spectrum-inclusive, or opposite, their mixture, the more light reflection is reduced.

VISUAL VIBES

Nineteenth-century color theorist Michel Eugène Chevreul used the term *simultaneity* to describe the balance-seeking nature of visual perception. He noticed that the eye, shifting immediately to a white surface after staring for thirty seconds at red, momentarily sees a *successive contrast* of green in a shape identical to the red. The brain seeks to restore equilibrium. As relief from the visual overload of red, what is missing (green) is generated as an "after-image."

Juxtaposed, complementary color intensities embolden. Each magnifies the other's vibrancy. In perfect balance, exactly opposite colors complete each other. One offers the segment of the spectrum missing in the other. Fatigued from looking at one color, the eye retreats to the spectral-remainder of the opposing color. A visual vibration effect accompanies the intensity boost of juxtaposed complements. Their boundary seems so unsettled that the colors appear to quiver. The eye, equally stimulated by both colors, seeks relief from one in the other and literally jumps back and forth between them.

The strongest vibration among common complementary color pairs exists between red and green, closely followed by blue and orange. Their value and intensity levels are closer than with yellow and violet, which vibrate least due to value difference.

The most visually dynamic of any complementary color combination is red-orange against blue-green because their values match at full intensity. When one color is dark, and another light, we tend to perceive objects against a background. (In spatial terms, shapes are perceived as positive/negative: objects = positive; surrounding space = negative.) Corresponding values make them equally luminescent, confusing the brain (value sameness reads as flat). The simultaneous depth/flat mixed messages cause an illusion of vibration.

Cadmium Red (red-orange) and Cerulean Blue Hue (blue-green) make a good complements match since the natural pigment brilliance of both further enhances vibrancy. The sample swatch on the opposite page makes a similarly balanced opposites-match. The eye seeks what is missing in the red-orange colored ground and finds relief in the blue-green paint patches. It returns to the ground color, seeking relief from the paint color, and on, and on. The vibration effect is heightened by value similarity. Note the absence of visual vibration when the same Cerulean Blue Hue is applied to white ground.

TURNING GRAY

Gray is a visual solvent. While considered achromatic, gray combines all colors, quenching the eye's desire for the spectral whole. In fulfilling that need, gray brings an emotionless calm.

Though gray lacks hue indication, it can lose neutrality through *simultaneity*. Neutral gray around any color, or surrounded by one color, takes on the appearance of that color's complement, thereby boosting the intensity of the color it juxtaposes. Gray within red visually tends toward green, within green appears red, surrounded by blue, begins to look somewhat orange, and within yellow, looks a little violet. Color context makes it look different. In an achromatic environment such as white or black, gray stays neutral.

Color purity and hue identity are best preserved if isolated from other colors. Context or ingredient changes alter appearance. Mixing or mingling with others can disguise true color identity. Against an *achromatic* neutral ground, color continues to look like itself. Neutral gray contains no hint of color, and therefore no potential for visually altering an adjacent color's hue appearance. Mixing a color with gray reduces intensity without changing hue. The term *tone* refers to a neutral version of a color, produced by mixing either with the opposite color or with gray (black and white).

DEPTH BY COMPLEMENTS

Juxtaposed or mixed, complementary colors create a visually perceived relief. Intensity stands out; dullness recedes. Complementary colors mingled, but not mixed, intensify, visually pulling the picture plane out. When mixed, complementary colors dull, visually pushing the picture plane back.

Referencing theory, artists learn to appropriately select colors and predict mixing results. With artists' colors, exact opposite matches should not be expected, nor are they essential. Any color resembling a color's complement can tone down its intensity. If, for example, green painted to represent leaves looks too bright, adding any color with obvious red content will tone it down. Complementary color interactions account for many of the tricks tucked up painters' sleeves. Depicting depth illusion is a common reason for mixing and mingling complements.

COLOR/GRAY CONTEXT. Simultaneous contrast causes the gray within each color to take on a look of that color's complement.

Sean Dye takes a varied approach to complementary color underpainting. Three different color tempera grounds began his *Portrait of Artist, Jon Young*: yellow-orange backdrop, red-orange for the shirt, and a green face. Between subsequent pastel strokes, ground colors show through in complementary contrast. Reds and oranges against green on the skin and shirt blues against red-orange make for greater contrast than do lighter strokes mingled with muted background underpainting. The background visually stays back in its dullness.

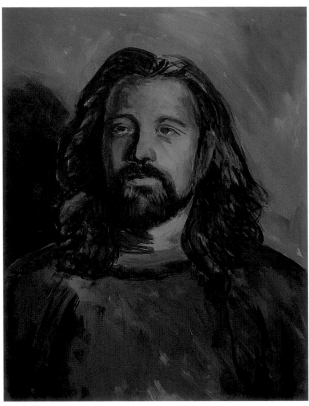

Sean Dye. *Portrait of Artist, Jon Young*, underpainting, 2003. Tempera on Pastelbord, 18 × 14" (45.7 × 35.6 cm)

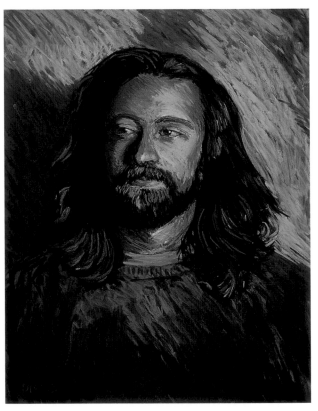

Sean Dye. *Portrait of Artist, Jon Young*. 2003. Pastel and tempera on Pastelbord, 18 × 14" (45.7 × 35.6 cm)
Collection of the artist

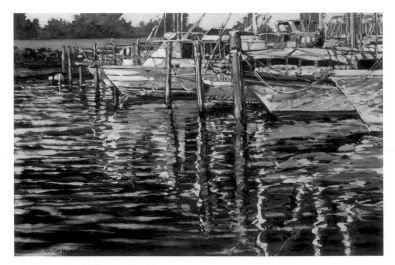

Caroline Jasper. *Tidelines*. 2002. Oil on canvas, 24 × 36" (61 × 91.4 cm)
Collection of the artist

Red, a very bright cadmium-like red, is the ground color for my oil paintings. Cerulean Blues prevail especially in foreground areas of *Tidelines*.

Caroline Jasper. *Tidelines*, detail. 2002. Oil on canvas, 24 × 36" (61 × 91.4 cm)

A close-up illustrates how I let the red-orange ground show through for a vibe effect against greenish-blue Cerulean. Dark/light contrasts in the same area add to complementary color contrasts, helping to support a visual pull forward.

The figure visually projects forward because it carries several different complementary, color-brightening oppositions.

Exclusive use of blue and orange, along with black and white, in my *Complementary Color Study* illustrates how mixing and juxtaposing complements can affect depth illusion. Unmixed colors brighten the foreground. Juxtaposed, blue and orange boost each other's intensity and generate a bit of visual vibration in light/shadow patterns on the little dish. Added yellow touches heat up the foreground. Orange appears in middle and background areas, but only under intensity management. If not toned down by mixing with blue or with black and white, the intensity and natural warmth of orange would contradict efforts to visually push the background back. Away from orange, blue's coolness recedes. Further back, blue's intensity fades with additions of black, white, and orange.

Caroline Jasper. *Complementary Color Study.* 2001. Oil pastel on paper, 19 × 12" (48.3 × 30.5 cm)

Caroline Jasper. *Amber Dawn.* 2000. Oil on canvas, 18 × 30" (45.7 × 76.2 cm)
Private collection

In *Amber Dawn* yellows and violets straight from the tube mingle unmixed in complementary opposition across the foreground. White highlight and dark shadow spots contrast within the boats, bringing them closer. Subdued mixed versions of the same complements fill the background. White added to a mix of complements completed the distant landmass. A final glaze of oil with white produced a distant atmospheric haze.

Bill James. *Cornucopia Ballerinas.* 2002. Transparent gouache on watercolor board, 19 1/2 × 27 1/2" (49.5 × 69.9 cm)
Collection of the artist

Depth illusion was established in *Cornucopia Ballerinas* with appropriate use of complements red and green. "Watching the ballerinas sitting on a table waiting to perform," James "loved the bright red and yellow tutus which formed a pleasing design when all in a row." Painting the background in subdued greens heightened the intensity of foreground reds.

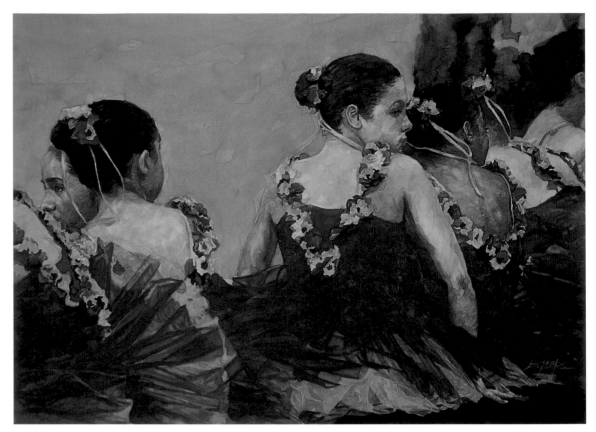

Camille Przewodek. *The Red Swimsuit.* 2002. Oil on primed linen, 9 × 12" (22.9 × 30.5 cm)
Private collection

Intensity and color complements create visual impact in Camille Przewodek's *Red Swimsuit.* A colorful yet subdued background fades while color intensities project a plain sandy foreground. In red, the small child grabs attention, but is countered by nearby complementary pairings. The green chair on red blanket, orange top next to blue, white hat and dark hair, all work together to upstage the red swimsuit.

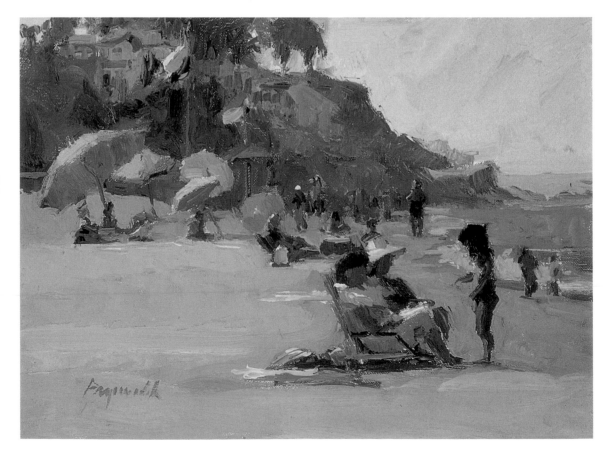

CONTEXT CONTRASTS

DIFFERENCES IN VALUE AND COLOR enable the brain to distinguish one thing from another. Establishing differences between object and background similarly contribute to the visual enjoyment of art images. In making paintings, artists repeatedly compare color and value contrasts between neighboring subjects and their parts.

Colors do not always look the same. Appearances shift with context. Colors next to one another on a flat surface tend to prompt a figure/ground response. One color is more aggressive, the other recessive; one seems positive, the other negative. Color appearance and visual interaction with adjacent colors depend upon the hue/value/temperature/ intensity of the figure and the ground.

Oils dabbed onto gesso, in a full palette sampling of each, were charted in order to predict how oil colors would visually interact on different colored grounds. Most noticeable are the value contrast combinations. Regardless of hue, dark colors show up better on light colors or visa versa. Colors of similar value visually blend more than those of related hue. For example, Crimson Lake is hard to distinguish on Cobalt Blue because both are dark. On Carmine, however, Crimson Lake stands out despite hue similarities. Color combinations with the greatest hue differences exhibit the most visual vibration, as in orange (Permanent Yellow Light and Crimson Lake mixed) on Cerulean Blue and green (Cobalt Blue and Permanent Yellow Light mixed) on Carmine. With increased viewing distance, colors that are more alike, in hue and especially in value, tend to visually blend to a third color, even though they are not literally mixed.

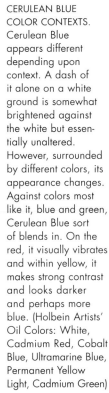

CERULEAN BLUE COLOR CONTEXTS. Cerulean Blue appears different depending upon context. A dash of it alone on a white ground is somewhat brightened against the white but essentially unaltered. However, surrounded by different colors, its appearance changes. Against colors most like it, blue and green, Cerulean Blue sort of blends in. On the red, it visually vibrates and within yellow, it makes strong contrast and looks darker and perhaps more blue. (Holbein Artists' Oil Colors: White, Cadmium Red, Cobalt Blue, Ultramarine Blue, Permanent Yellow Light, Cadmium Green)

OIL COLORS ON GESSO COLORS. Vertical stripes from left: Cobalt Blue, Cerulean Blue, Green, Yellow, Carmine (Holbein Gesso Colors); horizontal stripes from top: Crimson Lake/Cobalt Blue mixed, Cobalt Blue, Cobalt Blue/Permanent Yellow Light mixed, Permanent Yellow Light, Permanent Yellow Light/Crimson Lake, Crimson Lake (Holbein Artists' Oil Colors)

SIZE MATTERS

PROPORTION influences visual color effects. In a nonrepresentational composition of two colors, the color occupying more space generally reads as background. Relative size is both a compositional and communicational concern. Large fields of a single color dominate and attract attention. They may emphasize the most important subject or provide a unifying background. A color that prevails due to proportion implies more strongly its associative meaning.

Proportional effects are psychological. Dark value carries greater visual weight. Brightness is secondary. It takes more of a lighter color to visually compete with brighter or darker areas. Johannes Itten referred to it as "contrast of extension." Yellow visually balances violet in 3:1 proportions. It takes much more yellow than violet to create a mixture of the two that appears balanced between them. Similarly, when the same colors appear together unmixed, it takes a much larger area of yellow to visually stand up to violet's dark presence. Yellow is visually light and bright, yet violet's dark value visually outweighs the yellow. Red and green, similar in value, could visually balance in equal proportions. Harmony is achieved when color sizes are increased or reduced to compensate for value differences. Allowed to visually dominate by proportion, a color becomes expressive.

Patterns influence color interaction. Eyes cannot focus equally on all colors at once but sees them independently. Too many separate colors appear chaotic and confusing, separately demanding individual attention. Effects on each other magnify when enlarged, subdue when reduced in size. Large mingled patches of complementary colors visually vibrate. Proportion affects their visual impact. If small enough they may appear to mix creating the illusion of a neutral tone, like an intricate mingling of bright contrast color fibers in fabric.

The three rows of complementary pairings illustrated at left offer an analogy for pictorial depth: foreground/bottom, middle ground/center, background/top. Complementary colored checkerboards in the bottom row stand out more than do the same color juxtapositions on a smaller scale above them. Viewing distance changes the effect. Somewhere between inches from the canvas to yards away, color minglings meld into a mass of one generalized color, despite the fact that the colors are not literally mixed. The top row shows dull colored mixtures from each complementary pair. Premixed painted colors make for a flat look compared to the richer appearance of the same colors mingled/unmixed in small amounts.

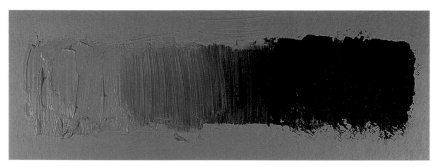

PROPORTION (YELLOW VERSUS VIOLET). Note the thin application of Permanent Violet compared to the thicker layer of Permanent Yellow. (Holbein Artists' Oil Colors)

COMPLEMENTARY PAIRINGS. Red/green, blue/orange, and yellow/violet are mingled in different proportions versus mixed.

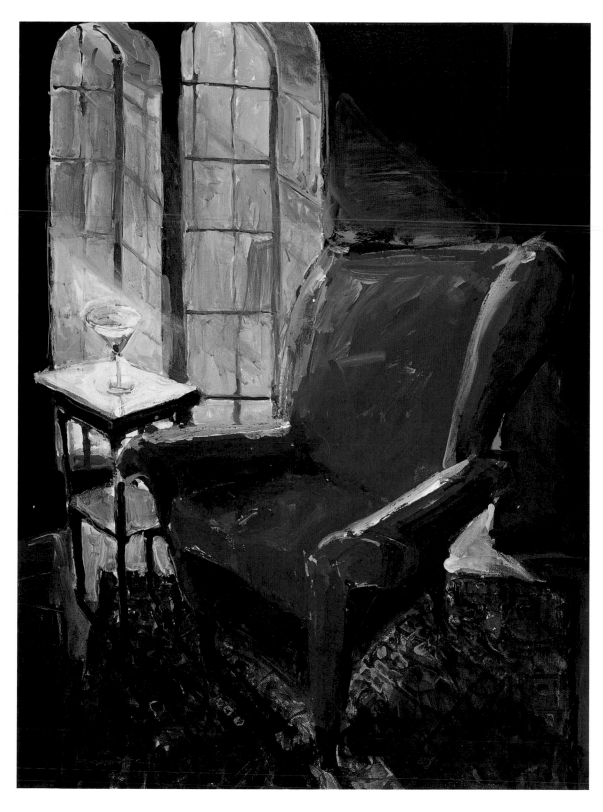

Robert Burridge. *Red Chair*. 2000. Acrylic on canvas, 30 × 40" (76.2 × 101.6 cm)
Private collection

Red Chair is one of a series emphasizing red, the artist's "favorite color." In abstract terms, that is a lot of red! The chair upstages a little martini glass attempting to hold the spotlight. Bold not only in size, the chair is eye-popping in its redness as well. According to Burridge, "The painting began as a warm monochromatic, working out the darks, lights, and the various values of his red, finishing with a not-too-subtle glaze of blue and cream right in the center." He finds that small touches of cool spots of blue scattered throughout the painting "add visual surprises." Without the variety of cooler and duller aspects framing the chair, its redness might not seem as glorious.

THEORIES IN RELATIVITY

COLOR THEORIES seldom apply exclusively. Thinking about warm versus cool color impact, an artist might emphasize yellows in strongly lit areas and blues in shadows. While focused on temperature theory, the influence of color values might go unnoticed. Yellow and blue, for example, make a natural match for temperature-value collaboration. Yellow is a warm and naturally light color. Blue is cool and usually dark. Intensity theory could further support depth illusion by incorporating brighter yellows and duller blues. Theories often work together.

Color character differences can be perplexing. Value contrast overpowers other color characteristics yet can be confused, instead of bolstered, by temperature and intensity. Yellow is brilliant yet light. If darkened, its intensity fades. Less vibrant colors overpower yellow in their darkness. Red at full saturation has medium to dark value. If lightened, it loses brilliance. It is better to think of color theories as concepts instead of rules. In the end, color sensitivity is biased by personal subjectivity.

Matisse, who cared little for doctrine, might object to a reference to one of his paintings in a color theory context. His unexpected color use was guided more by internal response than external prescription. However, a portrait he made of his wife, "The Green Stripe" (see page 61), clearly demonstrates an awareness of visual color interaction, in taking advantage of value's dominance over other color traits. Light from both sides produces a dark shadow down the center of Madame Matisse's face, represented by green. Though cooler than flanking yellows and pinks, green reads as shadow because its value is darker than adjacent warm colors. Bright colors appear in the background, yet complementary color contrasts centered on the face and value contrasts in facial details maintain the subject's forward position.

If colors could speak, paintings by Chuck Close (b. 1940) would scream like a riotous mob. Amplifying the visual chatter of Seurat's mingled but unmixed color dabs to sensory limits, and pushing to extremes Matisse's daring departures from local color, Close makes faces that vibrate with brilliant color interactions on a scale challenging interior space. From twenty feet away, his images read as shockingly realistic portraits. Stepping closer, colors dissolve into abstract blobs whose shapes and hues seem irrelevant to the sense of form and likeness they produce at a distance.

Though assessed as portraiture, Close's works indulge his fascination with process and resonate Josef Albers's color context and visual perception lessons. Regardless of how loose the paint application or how exaggerated the colors (magnified by scale), the overall effect creates a stunning illusion of form. With acute awareness of their natures, Close masterfully orchestrates colors' dark/light, bright/dull, warm/cool characteristics in mixed or mingled relationships. By working on such an enlarged scale, Close jolts viewers with the type of interactions between different color marks that are revealed in smaller-scale works only from close range.

In *Trail Lights* backlighting makes for dark forward cast shadows, interrupted by strong light and bright color. All that I do with color

Caroline Jasper. *Trail Lights*. 2000. Oil on canvas, 28 × 22" (71.1 × 55.9 cm) *Collection of Paul and Joyce Murphy*

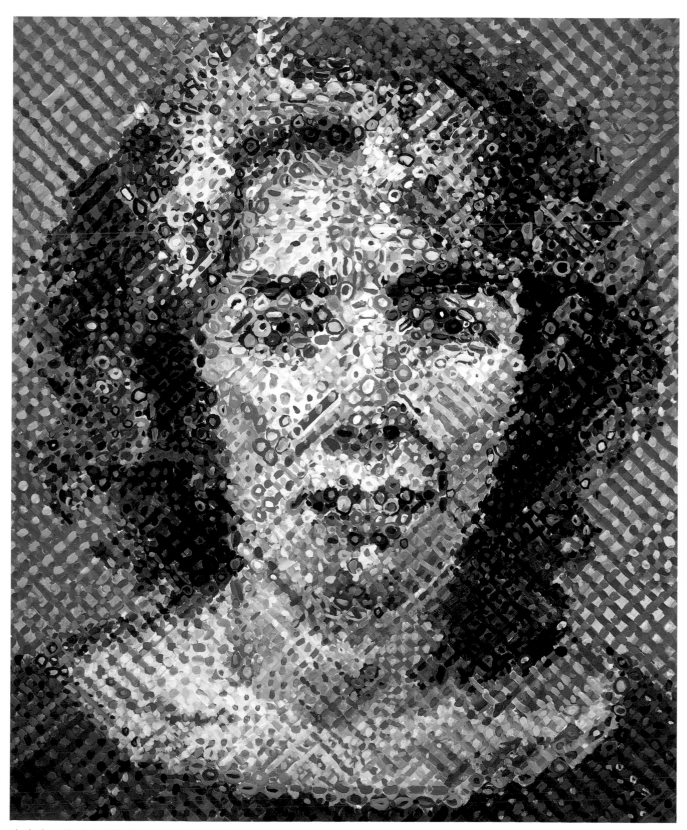

Chuck Close. *Elizabeth*. 1989. Oil on canvas, 72 × 60" (183 × 152.5 cm). The Museum of Modern Art, New York
Fractional gift of an anonymous donor. ©2003 Chuck Close

aims at getting back to the light show experienced at the scene. Every color theory I can conger up comes into play. Brighter, hotter colors occupy the foreground compared to the background's overall faded coolness. Value contrast is paramount. Dark/light differences increase toward the foreground while the background consistently lacks contrast.

Late afternoon shadow patterns drew Camille Przewodek's attention to the vineyard scene in her painting *Napa Sunset*. She started the shadows with Permanent Magenta and the light planes for the vineyards with Cadmium Orange. Eventually, she added green to both sunlit and shadow areas to give the illusion of local color seen under dramatic light. Oppositional complementary interplay supports that drama. Mid-ground yellows and yellow-oranges, decidedly warmer than foreground blues and violets, seems a contradiction to the warm/cool– near/far theory. As always, value overpowers all. Grapevine color darkness, and size, firmly anchors them to the foreground.

In his painting *Dinghies at Dinner Key*, Bill James played up complementary aspects of the scene's local colors. Color placements, with cool-colored boats in front of warm-colored water, potentially contradicted depth illusion. Yellow's visual projection tendency is managed. Toned down and faded with whites, the water stays back. Exaggerated color brightness along with strong light and dark touches keep the dinghies visually forward.

Tom Lynch's *Café Shadows* deftly coordinates color theories. He demonstrates the importance of color value over intensity and temperature. Complements violet and yellow make vibrant juxtapositions throughout the scene, in contradiction to their warm projecting and cool receding tendencies. Lynch compensates by managing value and intensity levels. Yellow fades into a background washed out by sunlight. Violet, intensified, mingles with brighter yellows in the foreground. Dark-by-nature violet against inherently light yellow creates the strong value contrast needed to bring the café forward. Even greater dark/light contrasts on the overlapping tree and left figures strengthen foreground presence.

Camille Przewodek. *Napa Sunset.*
2001. Oil on primed linen,
16 × 20" (40.6 × 50.8 cm)
Private collection

Bill James. *Dinghies at Dinner Key.*
1997. Oil on canvas, 22 × 30"
(55.9 × 76.2 cm)
Private Collection

BELOW: Tom Lynch. *Café Shadows.*
Watercolor on paper, 22 × 30"
(55.9 × 76.2 cm)

IN THE STUDIO: ROBERT BURRIDGE

ABOUT THE ARTIST

Robert Burridge is a painter in all media, national juror, college and national workshop instructor, and is president of the International Society of Acrylic Painters. Signature Member of both the Philadelphia Water Color Society and the International Society of Acrylic Painters, his honors include the prestigious Crest Medal for Achievement in the Arts and Franklin Mint awards. His work is featured in many books and magazines, on Starbucks Coffee mugs, tapestries, and Pearl Vodka bottles. Burridge's paintings are sold in galleries in San Francisco, Florida, and Australia. Burridge's country-barn studio is located on California's central coast in San Luis Obispo County.

COLOR PREMISE

In "Bobland," as Robert Burridge refers to his studio, the artist surrounds himself with vibrant color. Burridge's color thinking is more about making a painting than about mixing color. He believes that "passion is more conducive to creative result than technique." Mindful that color right out of the tube is the brightest it's going to be, he simply puts color down "for the sake of visual excitement and until the painting surprises" him.

His style explores and interprets "real life" in his own zealous voice. His intriguing Good Life series features tropical vistas, coastal landscapes, impressionistic still lifes, and luscious fruits and vegetables, all emboldened by painterly color. For Burridge, "If it's worth doing, it's worth exaggerating and overdoing." He paints with overstated color and light, expressive drawing, and tweaked perspective—"anything," he asserts, "to keep from falling back into a 'safe' painting zone."

COLOR METHOD

Robert Burridge loosely coats his canvas a mid-tone orange. Prior to painting, he determines goals first and then a color scheme to support and communicate a desired, purposeful, and meaningful result, such as the color of early morning light or late afternoon, or the glow of a sunset. He starts with a light brush stroke sketch of the layout and design composition in big bold shapes with no detail. He then blocks in the darkest darks and lightest lights having already determined the direction of the light source.

Burridge does not necessarily put in light washes and build from there. Instead, he goes for the immediate direct painting technique—*alla prima*. In multidirectional brush strokes, lightly touching the canvas with abrupt, staccato marks, he uses only pure color, never lingering with color dripping from his brush. He simply applies mounds of colors right from the jars on his table; there is no color mixing on the palette, just direct colors onto the canvas. He warns, "By whirling color around on a palette, it begins to dull down." He also avoids painting too long in any one area. If overworked, color becomes mud, losing the freshness that he's after.

Burridge strives to "just get the color down." He puts in one color, and immediately adds a surrounding color. For him, "painting is about color spots next to color spots." He has always been "turned on" by French Impressionists' effects, "interspersing opposite colors to create the illusion of light and air dancing all over the painting, and dabs of two colors visually creating a third color." (For example, short dabs of blue next to short dabs of yellow appear green when viewed from afar.)

It's not so much the actual color he uses that makes the accents so intense, but the adjacent or surrounding colors that help exaggerate or support a particular accent. Having painted "all color, all over, all the time" in his early work, Burridge began to tone or gray down some of the surrounding areas of color so as to emphasize the accented color spot. He works to "put color in and get out as quickly as possible." Using short, choppy strokes allows under colors to "peak through and shimmer."

Burridge often opposes color temperatures, painting objects in colors from the warm side of the color wheel and their cast shadows in cool tones. "This makes objects appear luminous," he claims. Conversely, however, he paints the darker side of a subject with its darker analogous color, instead of its complement. "The effect can be clean and juicy," says Burridge.

STUDIO PRACTICE

The artist's medium of choice is acrylic. Its fast drying time allows him to get desired results quicker than with oils or watercolors. He transfers acrylic tube paints

to widemouthed resealable plastic containers. Just enough water is added to make their consistency more conducive to spreading, flowing, and dabbing. Robert Burridge likes to produce a lot of artworks. He paints fast, furiously, spontaneously, and not cerebrally.

A typical day in his studio begins with opening quart jars of his favorite pure acrylic colors: primaries, secondaries, plus any "exotic and glorious" colors that currently interest him. The artist dips directly into each color jar with a brush, a twig, or his fingers. His brushes, elongated with sticks to typically thirty inches, help Burridge stay loose and free. Any mixing is done on the table palette. The artist stands to paint, his canvas placed flat on a low table surrounded by paint jars in color wheel order.

Through sequential treatments during the painting of *Private Table*, Burridge illustrates his direct pure color method. After starting with primary colors on his standard warm ground, he assigned other colors according to subject positions in the background or foreground. Subsequent color was added in response to compositional concerns and visual impact.

ARTIST'S PALETTE

Robert Burridge's favorite colors total thirty-four Holbein "Acryla" Acrylic Polymer Emulsion paints. However, his top preferred colors are: Chapel Rose, Orange Red, Cadmium Red Middle, Brilliant Pink, Yellow, Cadmium Yellow Middle, Cadmium Green Middle, Cadmium Green Deep, Cobalt Blue, Ultramarine Blue, Oriental Blue, Peacock Blue, and Rose Violet. Among all of the available colors, the artist's only prejudice is against the color brown. "Earth tones, such as Burnt Umber, Raw Sienna, Ochre, etc. are beautiful unto themselves," he says. But "I don't see brown in nature." Pure chroma colors "for the sake of pure colors" is what excites him.

Burridge's "palette" is a 4-x–8-foot plywood table, fifteen inches off the ground. On it he arranges containers of colors in the shape and order of a color wheel, or sometimes in an analogous arrangement. Because the colors are already laid out, he can freely paint without referring to any color chart.

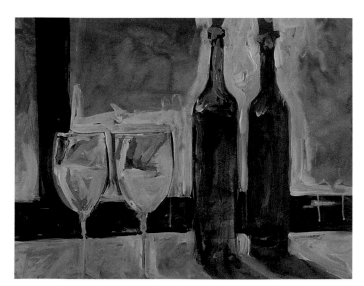

STEP 1. Over a dried orange-toned canvas, Burridge paint-sketched a simple and direct layout of the subject matter in primary red, blue, and yellow.

STEP 2. Burridge painted cool blue marks to indicate the fields in the landscape beyond the window and added hot colors to help the main subject—the wine bottles—to come "forward."

STEP 3. To separate the exterior from interior even more, other cool colors were added to the exterior, which diffused the details of rows of vineyards, so as not to draw attention to them. To hold the painting together, Burridge brought some of the blue inside, increasing foreground contrast.

STEP 4. Feeling the sky was too warm, Burridge unified the color with the addition of a light blue and developed more contrast overall. At this stage, he realized the painting still wasn't completed since he hadn't yet gotten to the "WOW."

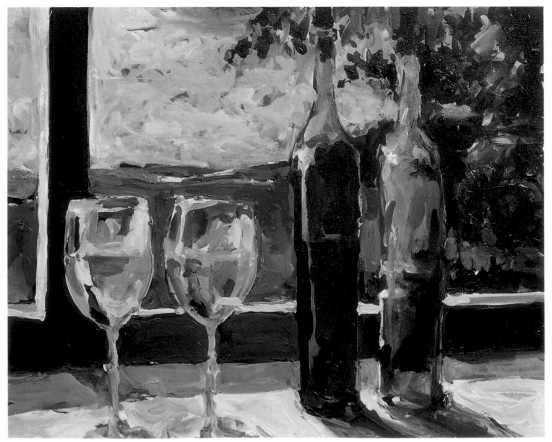

Robert Burridge. *Private Table.* 2002. Acrylic on canvas, 30 × 40" (76.2 × 101.6 cm)
Private collection

FINAL STEP. The "WOW" was created with a hot red glass of wine to "kick up that dead space on the right." The outdoor scene and color were both lightened and simplified.

COLOR CONCLUSIONS

Robert Burridge acknowledges that his formal education "proved invaluable." He credits the creative and technical experience of art school with teaching him to think on his feet, make decisions, right or wrong, and go at his painting with "unbridled passion." Years of daily painting brought him to realize that "Artists actually teach themselves to paint. Art education, workshops, and all the how-to books can teach what works, but artists have to get out of their chairs and make lots and lots of paintings." Burridge advises emerging artists, "You will make a lot of bad paintings before you can make a good painting. Everything you paint is not necessarily going to be a masterpiece. Remove that pressure from yourself and aim for the stars. You may only get to the moon, but at least you won't come up with a handful of mud." He further suggests, "Set goals, write more, visit museums, and take lots of painting workshops from many teachers. Take bits and pieces from each experience and fit them into your own personality, personal history, culture, and education to make your next best painting." He has always said, "It's never too late to be what you always should have been!"

IN THE STUDIO: CAROLINE JASPER

COLOR PREMISE

My premise *is* color. It dominates my thinking while painting. I want the rush of seeing rich colors, to enjoy thick brush marks of one color against another. It's a childlike awe I hope to never lose, putting down colors just to see them. Making paintings is a good grown-up excuse to do just that.

Choosing what to paint is an emotional decision. Like most living things I am attracted to light. It can enrich the most ordinary places and things. Each painting attempts to recapture a certain moment of light. I strive to somehow with color get back to how it looked and how I felt when I could not stop staring at a place temporarily improved by light. I find sunlight most appealing during early mornings and late afternoons. A low sun casts long shadows, increases color character contrasts, heightening the sense of form and depth.

Trying to impart what I see through painting forces me to think about *how* I see it. To make an image appear to have depth, I have to be able to see it as flat, because that is how it is painted. Rather than think in terms of near or far, as we do in relation to a three-dimensional world, I must think down or up, according to placement on canvas. Most essential to depth illusion is what happens with color.

While in progress, I frequently step back away from the easel to see if my work on the canvas is "working." At brush range, you get a behind-the-scenes view of how colors operate. Seen close-up, subject is secondary to light and color. If just the colors of light on everything are recorded, bits and pieces of painted color shapes will come together a distance away from the canvas to make a picture.

COLOR METHOD

Instructors who claim domain over "the" way (subtext: *their* way) have always struck a rebellious chord in me. My approach, in part, is in direct opposition to instruction. I was taught to prepare canvas with a turpentine wash of the previous day's palette remains, but doing so muddied painted colors. I found neutral-colored grounds bland and white canvas unacceptable because it camouflaged highlights until the end. I developed other methods.

I paint on a bright, hot red ground. Since there is no need to paint over every inch when a canvas is already colored, paints are less likely to become muddied. Ground color can separate colors painted wet next to wet, avoiding unwanted mixing. Also, by visibly permeating throughout, ground color unifies the painting. But why red? Red's fervent psychophysiology presents challenges worth facing. Its emotive implications fortify expression. From a color theory point of view, red is a middle color. Its medium-value ground contrasts both light and shadow. Red is darker than most other warm colors and a hot contrast against cool colors.

Red's visual aggression, its most powerful characteristic, can be managed. Covered or kept, it serves to visually push or pull, enhancing depth. Red's contrast with greens and blues causes visual vibration, effective in projecting foreground areas. It takes vibrant straight-from-the-tube color to match the red ground's intensity. Its visual activity is bold. Each color patch adds another piece to the puzzle creating new context relationships. I try to get color right on first application, but return as needed tweaking value, temperature, or intensity.

On location, I shoot many photographs and also take time to absorb the sense of place. Having been there is essential for me. Back in my studio, the photographs prompt a memory of the moment.

STUDIO PRACTICE

Oil paint is butter. I find it more visually appealing, pleasing to handle, and more versatile than any other medium. For their color brilliance and spreading constancy, I prefer Holbein oils.

A 50/50 mix of Holbein's Carmine and Orange gesso colors forms my red ground, a vibrant red-orange much like Cadmium Red. The red gesso is top-coated over standard gesso-primed canvas.

I paint sunlight first, establish value contrast early, and then work colors to push/pull for depth. All the while, color choices are influenced by striving to reclaim the attitude of the moment. I mix colors on my canvas more than on my palette, seldom combining more than two. Once color is covering the entire canvas, I simplify areas by massing like colors. As a final treatment, after the surface is hardened and dry to the touch, I apply glaze to simplify and exaggerate light and shadow, enhancing depth.

Images of *Fall Still* in progress, typify my approach. It presents what I generally do, but it's not a formula. Each painting calls for unpredictable departures from standard practices.

ARTIST'S PALETTE

My palette is founded on dual primaries with warm and cool versions of each to maximize mixing potential. The core colors include Cadmium Yellow and Cadmium Yellow Lemon, Cadmium Red and Crimson Lake, plus Ultramarine Blue and Cerulean Blue. Added favorites include Sap Green and Viridian (dual greens; one warm, one cool), along with Cadmium Orange, Permanent Violet, Cobalt Blue, and Indigo, plus Permanent White. No black. I prefer Holbein Artists' Oil Colors for their pigment saturation and buttery consistency.

My typical palette. Grouping colors by similarity precludes muddy mixtures. I often group dark colors and place yellows next to white. The color wheel layout shown is a start-up arrangement. It often becomes disorderly or fragmented depending upon what the painting needs at the moment.

STEP 1. *Sunlight.* Everything hinges on light. Sorting out a value plan in simple terms at the start supports final image impact. To suggest a range of lighter values, white, in varied thickness, goes on the red ground first. All unpainted areas will be medium or dark values. Color introduced in subsequent applications reduces most of the white's starkness—a little Cerulean Blue to tint the sky and Cerulean Blue with Cadmium Lemon Yellow to differentiate background and middle ground lightness. In the finished painting, the unmixed whites will become more important to foreground water highlights.

STEP 2. *Value contrast.* Red becomes the middle value as darks are recorded using mixtures of the darkest colors on the palette—Ultramarine Blue, Crimson Lake, and sometimes Viridian. On red ground, transparent colors look much darker than if painted over white gesso. Painting into wet whites creates grayed tree limbs in the background.

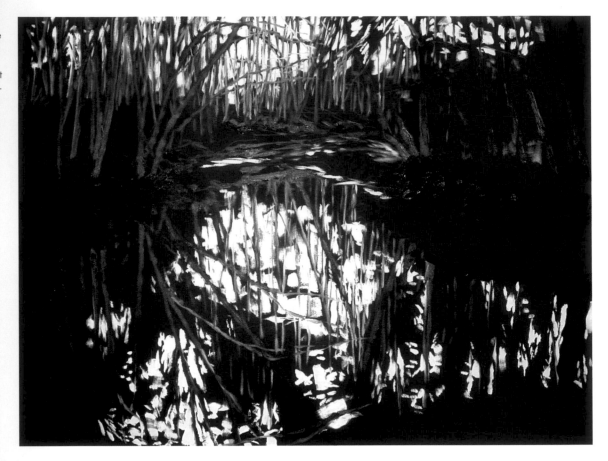

STEP 3. *Light variations.* With value extremes established, lighter values gain color. Lighter colors (Cadmium Yellow, Cadmium Yellow Lemon, and mixtures containing either) applied on the red ground and tints from darker colors painted into wet whites add interest to lighter areas.

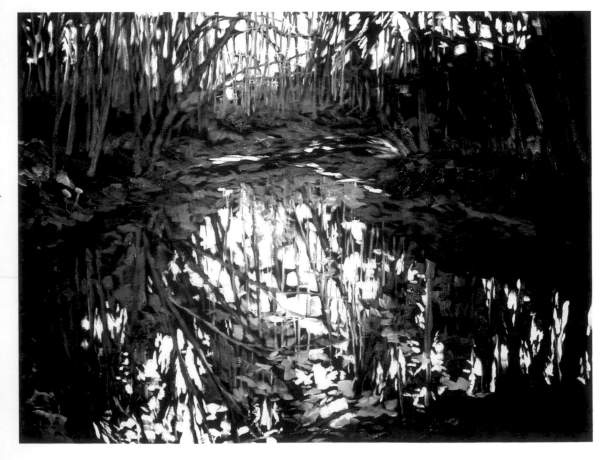

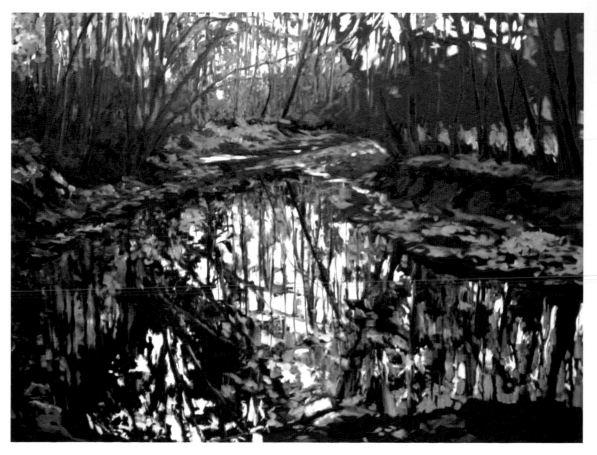

STEP 4. *Dark variations.* Darker-valued colors (Sap Green, Viridian, Ultramarine Blue, Crimson Lake, and different mixtures of them) define shadows. Some "black" areas are left as originally painted while others mix with newly applied colors.

STEP 5. *Foreground detail.* More red is pronounced. Larger portions of the red ground are left unpainted in near foreground areas. Red's aggression visually projects the foreground. Its vibration with brighter greens reinforces the effect.

STEP 6. *Color all over.* Middle-valued colors (Cadmium Orange, Permanent Green Light, and mixtures with Sap Green, Permanent Violet, etc.) establish an overall image. Whether to keep or cover the red ground is determined in all areas.

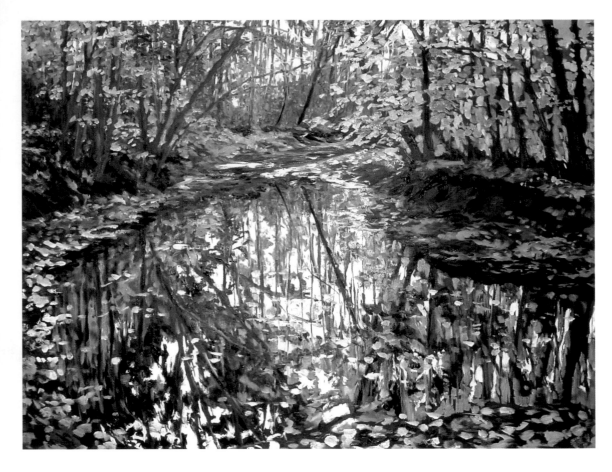

COLOR CONCLUSIONS

Although a teacher of many years, I strive to continue being a student. Color theory study is important, but you still have to sort it out for yourself. Find your own mentors. Study the art and writings of those whose work you admire. Among my heroes, those who dared new ways with color, are Monet, Van Gogh, Matisse, Maxfield Parrish, Hopper, Porter, Thiebaud, and Close. Learn all you can and keep only what applies. Make your own "rules" (the only ones worth following), but be willing to break them.

STEP 7. *Background detail.* Most of the red ground, except for small bits, is painted over in distant areas. Its presence in the background is visually contradictory to depth illusion. To avoid diluting their intensity, overlapping brighter colors of mid-ground trees are painted after background colors have had several days to harden.

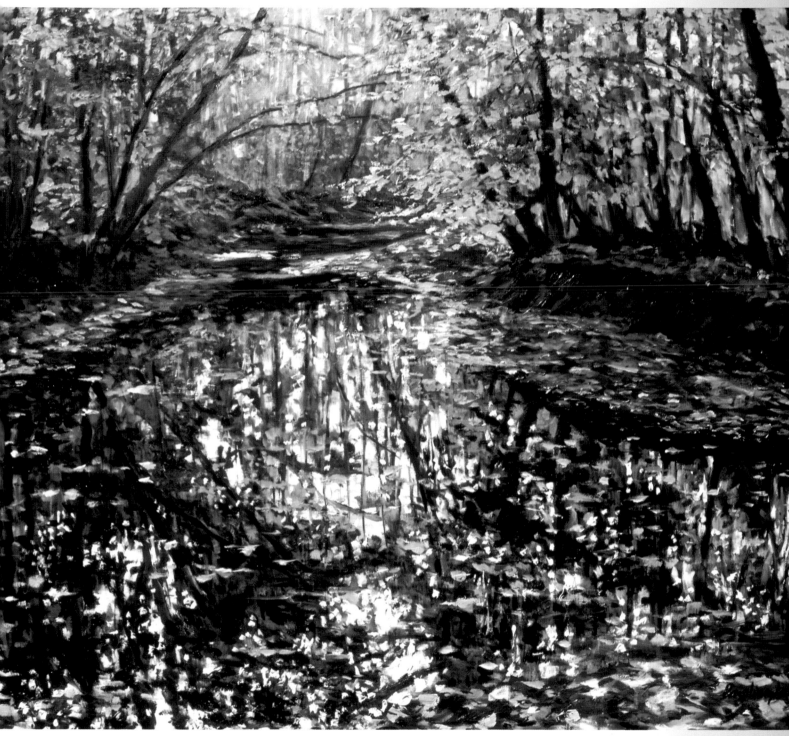

Caroline Jasper. *Fall Still.* 2002. Oil on canvas, 30 × 40" (76.2 × 101.6 cm)
Private collection

FINAL STEP. *Contrast push.* In the end, concerns return to value contrast. With such hot colors dominating at mid-ground, dark/light differences in the foreground become all the more essential. Dashes of "fattened" white (extended with oil medium, adhering to the "fat over lean" principle) add sparkle to foreground water reflections. Nearby shadows are deepened with Indigo. Once dry to the touch, distant foliage is visually pushed back into haze, brushed over with a bluish-white glazing.

ACKNOWLEDGMENTS

TREMENDOUS THANKS goes first to my husband, Eric, for his encouragement along with his patience and tolerance during my lengthy disappearances into these pages. I also acknowledge the support of the rest of my family: my children, Lauren Gerberich, Dustin Gerberich, Kerrie DeVito and her husband, Joseph, and Matthew Jasper; my grandson Matthew Jasper, Jr.; my mother Caroline Long; my mother-in-law Jean Jasper; and my sister Priscilla Kanet.

I greatly appreciate the contributions of artists Robert Burridge, Jeanne Carbonetti, Sean Dye, Bill James, Abby Lammers, Tom Lynch, Thomas Nash, Camille Przewodek, and Kitty Wallis, whose works and words enrich this book.

I am grateful to the Hopper brothers, Douglas and Timothy, at HK Holbein for their many contributions. The assistance of friends Joyce Murphy, regarding research, and Bruno Baran, for digital image enhancements, is also appreciated. I am indebted to Watson-Guptill for the opportunity to write this book and especially to the fortitude and guidance of Senior Editor Joy Aquilino and to the invaluable expertise and thoroughness of Editor Holly Jennings. Designer Areta Buk and Production Manager Hector Campbell also deserve a word of thanks for their part in helping to make this book come together.

BIBLIOGRAPHY

Albers, Josef. *Interaction of Color*, rev. ed. New Haven and London: Yale University Press, 1975.

Birren, Faber. *Principles of Color*. Atglen, PA: Schiffer Publishing, 1987.

FitzHugh, Elisabeth West, ed. *Artists' Pigments: A Handbook of Their History and Characteristics*. New York: Oxford University Press, 1997.

Gage, John. *Color and Culture*. Berkeley and Los Angeles: University of California Press, 1993.

Gross Anatomy of the Eye. January 2001. http://webvision.med.utah.edu/anatomy.html.

Hawthorne, Mrs. Charles W. *Hawthorne on Painting*. New York: Dover Publications, 1960.

Itten, Johannes. *The Art of Color*. Trans. by Ernst van Haagen. New York: Van Nostrand Reinhold, 1973.

Janson, H.W., and Anthony F. Janson. *History of Art*, rev. 6th ed. Upper Saddle River, NJ: Prentice Hall, 2004.

Le Clair, Charles. *Color in Contemporary Painting*. New York: Watson-Guptill Publications, 1991.

Livingstone, Margaret. *Vision and Art: The Biology of Seeing*. New York: Harry N. Abrams, 2002.

Mayer, Ralph. *The Artist's Handbook*, rev. 3rd ed. New York: The Viking Press, 1970.

Miller, Neil R., and Nancy J. Newman. *The Essentials: Walsh & Hoyt's Clinical Neuro-Ophthalmology*, 5th ed. Baltimore: Williams & Wilkins, 1999.

Mittler, Gene A. *Art in Focus*. New York: Glencoe/McGraw-Hill, 1994.

Pyle, David. *What Every Artist Needs to Know About Paints and Colors*. Iola, WI: Krause Publications, 2000.

Quiller, Stephen. *Color Choices*. New York: Watson-Guptill Publications, 1989.

Sargent, Walter. *The Enjoyment and Use of Color*. New York: Dover Publications, 1964.

Sayre, Henry M. *A World of Art*, 4th ed. Upper Saddle River, NJ: Prentice Hall, 2002.

Spike, John T. *Fairfield Porter: An American Classic*. New York: Harry N. Abrams, 1992.

Stromer, Klaus, et al. *Color Systems in Art and Science*. Trans. by Randy Cassada. Constance: Regenbogen-Verlag: Edition Farbe, 1999.

Wilcox, Michael. *The Artist's Guide to Selecting Colors*. Perth, Western Australia: Colour School Publishing, 1997.

Wright, Kenneth W. *Ophthalmology*. Baltimore: Williams & Wilkins, 1997.

INDEX

CREDITS